Comickers

Write Amazing Manga Stories

Art ③

Write Amazing Manga Stories

Comickers
Write Amazing Manga Stories

Art ③

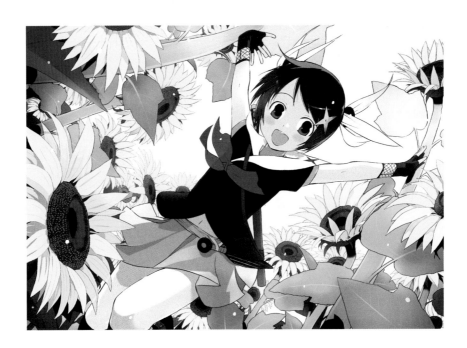

Comickers Magazine

COLLINS DESIGN
An Imprint of HarperCollins Publishers

Comickers
Write Amazing Manga Stories
Art ❸

Comickers Art 3: Write Amazing Manga Stories
Copyright © 2008 Bijutsu Shuppan Publishers Co., Ltd.

All rights reserved. No part of this book may be used or reproduced in any manner whatsoever without written permission except in the case of brief quotations embodied in critical articles and reviews. For information, address Collins Design, 10 East 53rd Street, New York, NY 10022.

HarperCollins books may be purchased for educational, business, or sales promotional use. For information, please write: Special Markets Department, HarperCollinsPublishers, 10 East 53rd Street, New York, NY 10022.

This book was first published in 2007 in Japan by:
Bijutsu Shuppan Publishing Co., Ltd. under the title of
Comickers Art Style Volume 2

First published in 2008 by:
Collins Design
An Imprint of HarperCollinsPublishers
10 East 53rd Street
New York, NY 10022
Tel: (212) 207-7000
Fax: (212) 207-7654
collinsdesign@harpercollins.com
www.harpercollins.com
through the rights and production arrangement of
Rico Komanoya, ricorico, Tokyo, Japan

Distributed throughout the world by:
HarperCollinsPublishers
10 East 53rd Street
New York, NY 10022
Fax: (212) 207-7654

English translation: Seishi Maruyama
English copy-editing: Alma Reyes-Umemoto
Book Design and Art Direction: Atsushi Takeda (Souvenir Design)
Typesetting: Yuko Ikuta (Far, Inc.)
Editorial Assistant: Aki Ueda (ricorico)
Picture Research: Yuri Okamoto
Chief editor and production: Rico Komanoya (ricorico)

Library of Congress Control Number: 2007938855

ISBN: 978-0-06-145207-9

Printed in China by Everbest Printing Co., Ltd.

First Printing, 2008

Contents

1

Artists and the World Act to Them

cording

Creating a Story

Original text: ELSEWARE Ltd. (Takeshi Yashiro, Toru Takasaki)
Illustration: Tetsuya Nakamura

One of the most important elements in manga creation is the story. Many manuals are available that explain the manga writing method. Yet, attractive stories can be created from four essential factors, which are enumerated in the following section.

A Good Story Remains in People's Hearts

Manga, novels, movies, games, and soap operas can have original stories, but they may fail to impress if their audiences cannot remember them after a period of time. A good story should remain in people's hearts forever.

Importance of Basic Story Patterns

Many people think that successful heroes/heroines, beautiful romances, and intriguing plots filled with action and cool characters are the elements that remain in people's minds. However, stories created from a basic structure tend to be the most impressive.

Hollywood films, for example, consist of a basic story pattern: one day, the main character suddenly gets into trouble and enters an extraordinary world; he or she tries to find clues to the mystery to get out of trouble, but discovers a greater mystery behind the present conflict that is closely related to him or her; he or she decides to confront this mystery and engages in a battle. This basic pattern is often found in popular books.

Monitoring a Logical Development in the Story

A story pattern often follows story-telling rules, such as "Ki-Sho-Ten-Ketsu" (Introduction-Development-Turn-Conclusion) and "Jo-Ha-Kyu" (Beginning-Climax-End), which are especially observed in the entertainment world, such as manga, games, and other media. These rules are sometimes broken, but beginners should follow them thoroughly (see pages 14-15).

Some works with broken stories sell well. They are created with meaningless plots on purpose: A man goes on a journey to avenge his father and ends up marrying the princess of a neighboring country without avenging his father. Such stories are considered broken. A piece of work may sell well despite its broken contents, but the story itself may not be evaluated in a positive manner. It is important to create an interesting as well as a marketable story.

POINT 1

Character Creation—the Most Important Factor in Building a Story

One of the most important elements in story composition is the character. A story evolves around well-developed characters. The following pointers explain the secrets in creative character composition.

Close Relationship Between the Story and Characters

The story and the characters are important elements in a manga and are closely related with each other. Start creating your story by building the characters.

Thinking About the Character's Personality

In character creation, creators often consider first the characters' physical features, clothing, height, and appearance. Physical appearance is important, but it is wise to start by focusing on the character's internal features, such as his or her point of view and personality.

The followings pointers are necessary in designing the character's internal features.

1. Decide a purpose for creating your character.

Assign a goal for your character. He or she may want to become someone or to do something. Characters develop by aspiring to a purpose and striving to reach it; consequently, a story narrates this process.

2. Give your character motivation.

A character may become insignificant if he or she does not have a purpose or goal. He or she should have the motivation to answer why he or she was created. The character should satisfy key phrases, such as "For the purpose of..." or "Because..."

3. Plan the setting.

Plan the setting to justify the character's motivation. You can determine specific ways that help your character achieve his or her goals, or define his or her background and personal relationships. These are basic elements to consider in setting up your characters.

4. Connect the motivation and the goal.

List the character's purpose and motivation and arrange them coherently by using phrases and sentences for better comprehension. For example: "For the reason of... (setting a motivation)" → "For the purpose of... (motivation)" → "By doing this... (setting a goal)" → "Try to... (goal)." Organize your ideas into a flow chart as indicated below.

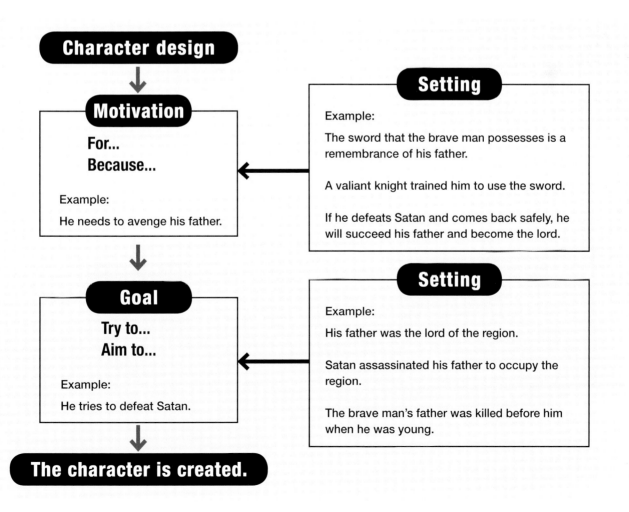

Character design

↓

Motivation

For...
Because...

Example:
He needs to avenge his father.

↓

Goal

Try to...
Aim to...

Example:
He tries to defeat Satan.

↓

The character is created.

Setting

Example:

The sword that the brave man possesses is a remembrance of his father.

A valiant knight trained him to use the sword.

If he defeats Satan and comes back safely, he will succeed his father and become the lord.

Setting

Example:

His father was the lord of the region.

Satan assassinated his father to occupy the region.

The brave man's father was killed before him when he was young.

POINT 2

Skills for Explaining a Story Briefly

A good and attractive story is not meaningful if it cannot be understood. It is important to create not only a final, polished product, but also to be able to explain the story in a brief outline using short phrases. A good story also depends on how much you understand its basic structure.

Importance of Explaining the Story

People may think that your story is so good that no one can come up with the same idea. Your story may be action-packed, or a love story about a good-looking pirate, or it may be about a dwarf who attends a Japanese high school and involves the students in great chaos. It could also be a sad love story about a beautiful princess confined in a kingdom of darkness. Many types of characters and thoughts can shape different types of stories.

The stories mentioned above do not give us any clue about their plots by just reading the descriptive lines, except for the setting and the protagonist. If you tell or explain your story to a friend or a publisher, it will not be enough to describe your story in a few sentences if you want it to be understood. You need to transmit your ideas with accuracy, then you will be able to receive some opinions or comments about them—this is very important.

How can you explain your story with accuracy?

Stories That Reflect Changes in the Character's Psychological Behavior

When you complete the fourth point in character creation (connecting motivation and goal), list the character's motivation, goal, and setting, and rearrange them along a natural flow. Try to imagine vaguely not only the characters' profiles but also the story itself.

The explanation of a story and the development of characters are similar because a story and its characters have a close relationship with each other. The story forms changes in the psychological behavior of the characters. When you explain your story, describe what the characters do and how they develop in the end. A shortened explanation of the story is called the plot.

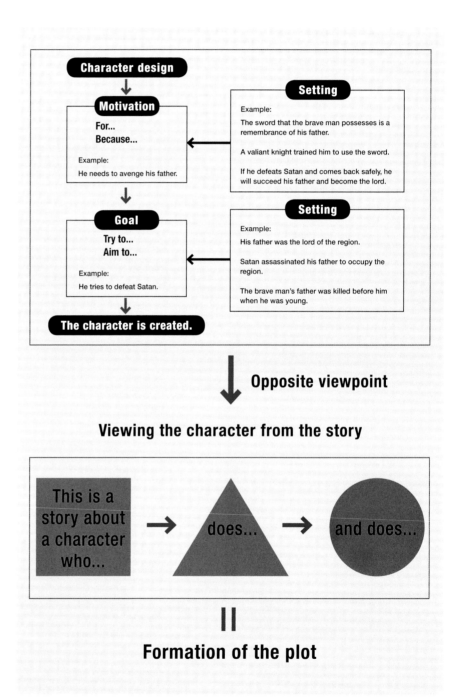

In the description for character creation as shown on the previous page, the viewpoint was outlined as: "The character is... → thus, the story is..." The diagram below shows the opposite viewpoint: "The story is... → thus, the characters will..."

In explaining your story, try to select the important events and list them in chronological order. Organize the contents while selecting minimal topics to explain your story.

Summarizing the Story in a Short Sentence

Try to organize your story thoroughly. Then describe it using a short sentence, such as "It is a story about... doing... and..." You can practice by describing the stories of your favorite manga, novel, and animation likewise in short sentences. By reorganizing and summarizing your story, you will be able to better understand the plot and appreciate how the characters develop in the story.

What Is a Plot?

The plot is the summary of a story that is expressed in short sentences. The dictionary defines the term "plot" as "an outline." It is a simple explanation of the story using minimal words without expressions of time, such as "a story of... who does... and does..." The plot is an important and fundamental element of a story.

Outline and Synopsis

The plot does not easily grasp the entire picture of the story. You need additional explanations in more detail, which are the outline and the synopsis.

An outline is a rough description of the entire story. It not only describes the characters and scenes but also incorporates the dialogues and psychological elements of the story. You can itemize the descriptions in sentences or roughly sketch them using manga frames.

A synopsis consists of summarized short sentences of the entire story and includes the conclusion. The synopsis written on the cover of a comic book is a bit different as it aims to draw the readers' attention and interest.

Different Types of Summary

Elements for Building a Story

Plot
Phrases that expresses the story directly without chronological order. For example: "a story where the character... does... and does..." It is the foundation of a story.

Outline
A rough description of the entire story in chronological order that can be itemized in sentences or roughly sketched in manga frames.

Elements for Selling the Story

Synopsis
A brief flow of the entire story that is summarized in chronological order and includes the conclusion.

Story Hook
An outline with a mysterious or suspenseful description of the conclusion, or a setting that draws or "hooks" the readers' attention. A short catch phrase may serve as the story hook.

In the diagram above, the elements for building a story are categorized into four factors for better comprehension. The grouping can vary or use different terms depending on the field of art.

Incorporating Opposing Structures

Your story can include opposing structures, such as the personal relationship of a boss and his employees, concepts of justice and evil, and the conflict between Western and Eastern civilizations. Your character's mind swings between opposing elements, making him or her confused, and compelling him or her to make a decision.

Story Development Using Multiple Choices

A story monitors the character's growth and psychological changes. However, an obscure description of the character's growth process is not enough to create an interesting story. Otherwise, the story will become boring and monotonous.

The story becomes lively when the character faces various concerns, troubles, mysteries, and enemies that he or she needs to overcome. When a character encounters these obstacles, he or she must make a choice, for example, between upholding justice or committing an evil act to obtain what he or she wants; or maintaining the status of a prince or marrying a plebeian lover. Some stories may pose three or four choices, but you can always narrow them down to two: the major and minor choice.

The opposition of good and evil and the conflict in a character's mind constitute the foundation of a story's construction, which is also called the story structure.

Grasping the Story Structure and Eliminating Contradictions

In grasping the story structure, you should be able to plot the direction in which the story develops.

For instance, there's a story about a horseback rider who was transformed by an evil organization and struggles with his past. He fights for justice and wins using a special power given to him by the evil counterpart. This story is based on a structure of justice versus evil. However, if the story were about a man from an evil organization who struggles with his past and seeks a successful career, the plot holds no intrigue because it does not embrace the conflict of justice versus evil.

When you expand your story or add more characters, you can avoid the error of inserting an inconsistent or contradictory episode (which often happens when you add elements without planning) if you clearly understand the structure of your story. You can incorporate a new concept by adding elements that are not found in traditional story structures.

In the previous story example, if the goal of the horseback rider is to be successful in his career as a company employee, you can still frame the structure to reflect justice versus evil by inserting a scene where he transforms himself to fight against the evil company executives who dominate the business. You can also create a story about daily work that reflects the story structure of justice versus evil.

Having More Than One Story Structure

A story structure is not necessarily based on only one story but may also have several. There may be only one story structure from one point of view, but by looking at it from different views, or by focusing on other relationships, you may find another story structure.

For example, in a story about two rival skaters in a figure skating club, one skater is clumsy and always fails in everything; the other skater is a beautiful, genuine upper-class lady and is a better skater. There are various structures in this plot, such as commoner versus upper class, vigorous

Examples of Oppositions and Conflicts

Emotion	Like vs. Dislike
	Humility vs. Greed
Concept	Justice vs. Evil
	Nobility vs. Vulgarity
	Eastern vs. Western
	Science vs. Witchcraft
Human Relations	Male vs. Female
	Parent vs. Child
	Self vs. Others
	Boss vs. Subordinate
Organization	Individual vs. Company
	Private Citizen vs. Public Office
Environment	Human Civilization vs. Natural Environment

Drawing scenes of good and evil is familiar to manga illustration. The manga story usually depicts a structure of good and evil factors opposing each other wherein the character struggles and develops himself.

training versus inborn talent, winning versus losing, and more.

The two skaters develop a friendship even though they are rivals. Meanwhile, a good-looking male student appears. The two girls fall in love with the same man. They both know that their friendship is important, but they both want to go out with the same man. This causes a strain in their relationship. Here, a new structure of friendship versus love is created.

Understanding the Story Structure Using an Opposition and Conflict Chart

• A and B refer to the opposing or conflicting characters.

• The story advances from the introduction to the conclusion.

• An arrow represents the movement of the character's psychological behavior.

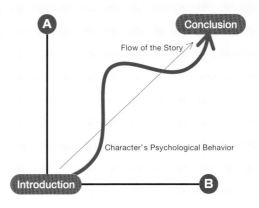

The story shown above has a structure of A and B opposing and struggling with each other.

The arrow's curve may vary depending on the story's content or the final decision the characters have made.

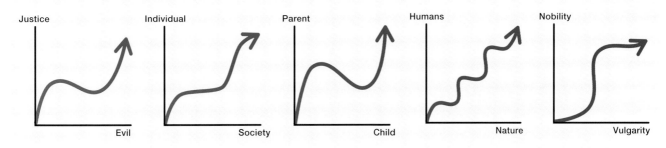

The graphs shown above facilitate the comprehension of a story structure. Opposing factors and conflicts correspond to the vertical and horizontal axes. The main character moves from the lower left zone toward the conclusion in the upper right section. He or she encounters oppositions and conflicts during the course of the story.

POINT 4

Creating the Story Flow

The secret to a story's total organization lies in the use of an effective flow system. Manga artists and writers explain the basic concept of manga story creation through a story flow, from the introduction to the conclusion. This concept is called the "Ki-Sho-Ten-Ketsu" or "Jo-Ha-Kyu" as used in Japanese terminology.

Thinking About the Story

When you have gathered your ideas for your characters, materials, scenes, and other story elements, including the plot and story structure, collate them into a story. List as many scenes as you can think of to build the synopsis. You don't have to focus on their order, rather list them randomly as you take down notes.

Dividing the Story

After listing the scenes, arrange them to form the storyline. A story must have a flow and the scenes must be connected with each other along this flow. Then, break up the story into several parts using the important methods of "Ki-Sho-Ten-Ketsu" and "Jo-Ha-Kyu."

Ki-Sho-Ten-Ketsu (Introduction-Development-Turn-Conclusion)

This method originates from the story creation method used in Chinese poetry but can be applied to all types of stories. It consists of four components.

Ki: This is the introductory part that presents the characters, personal relationships, scenes, locations, and other elements. It also functions as an eye opener to draw people's attention while incidents that provoke the characters' involvement with mysteries are presented.

Sho: This is the transition from Ki to Ten. At this stage, there is not much significant development in the story yet. Sho is used to expand the incidents and mysteries presented in Ki and to connect them together.

Ten: This is the most exciting part that adds changes in the story. A strong enemy may appear in the scene, or the truth is revealed and the characters' incentives change. The story advances toward the conclusion.

Ketsu: This part refers to the conclusion, which is called "Ochi" in Japanese. The peak of the story is concluded here, wherein an enemy is successfully defeated or all the mysteries are solved. There may be an addition or a sequel to the story that will answer the mysteries in the end—or a suspense may also be held.

Jo-Ha-Kyu (Beginning-Climax-End)

This structural method is used in Gagaku music (Japanese ancient classical music) or the Noh play. It is less popular than Ki-Sho-Ten-Ketsu, but both concepts are similar. It consists of three components.

Jo: This is the introductory part of the story that roughly corresponds to Ki and Sho.

Ha: At this stage, the story changes and becomes more exciting, corresponding roughly to Ten. In some styles of Gagaku, Ha is divided into three parts: Ha no Jo (introduction), Ha no Ha (evolution), and Ha no Kyu (conclusion).

Kyu: This is the conclusion and roughly corresponds to Ketsu.

Midpoint

A useful idea that is used to create the story flow, as done in Ki-Sho-Ten-Ketsu and Jo-Ha-Kyu, is called the midpoint of the story. It is similar to Ten, except at this stage the story changes between the first and second

What Is a Midpoint?

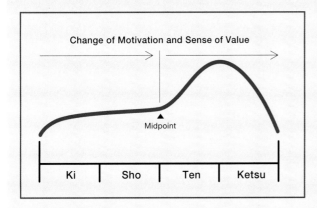

Change of Motivation and Sense of Value

Midpoint

Ki | Sho | Ten | Ketsu

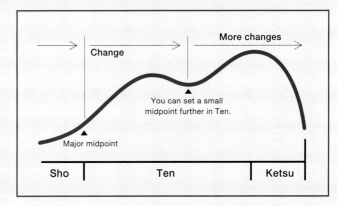

Change

More changes

You can set a small midpoint further in Ten.

Major midpoint

Sho | Ten | Ketsu

Example of Ki-Sho-Ten-Ketsu

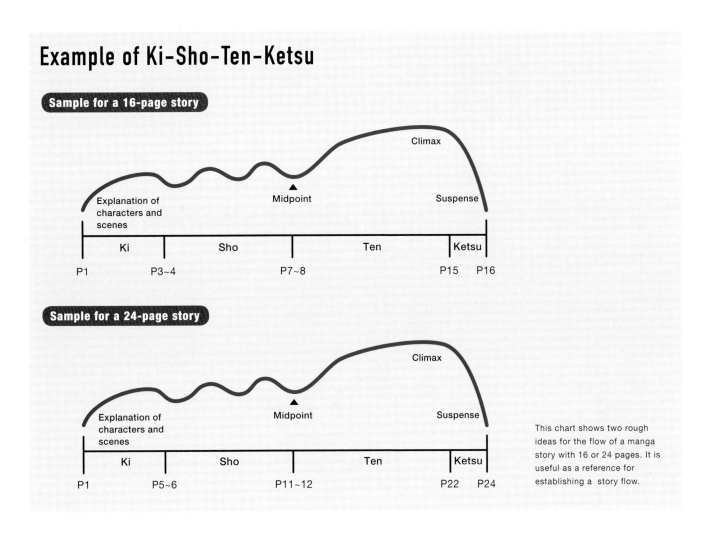

Sample for a 16-page story

Climax

Explanation of characters and scenes

Midpoint

Suspense

| Ki | Sho | Ten | Ketsu |

P1 P3~4 P7~8 P15 P16

Sample for a 24-page story

Climax

Explanation of characters and scenes

Midpoint

Suspense

| Ki | Sho | Ten | Ketsu |

P1 P5~6 P11~12 P22 P24

This chart shows two rough ideas for the flow of a manga story with 16 or 24 pages. It is useful as a reference for establishing a story flow.

halves in terms of the character's motivation and sense of value. For instance, a protagonist suddenly gets into trouble and discovers the solution or the clue to the mystery as he tries to escape from it. If we define this part as Ki and Sho, Ten follows, and this part is the midpoint. Then, a bigger mystery occurs that is related to the protagonist. He challenges this mystery and sets out for the final battle. This structure is seen as: escape→challenge, run away→offense—we observe the protagonist's change of motivation, which sets the midpoint in the story.

This story flow shows how you can expand your story or add depth to it. It is possible to organize the story details clearly by repeating scene patterns within Ki-Sho-Ten-Ketsu or Jo-Ha-Kyu. You can also set a midpoint within Sho or Ten. In this way, the story develops further and becomes more exciting as events turn around twice or three times to draw the readers' attention.

Incorporating Underplots After Grasping the Entire Story

A well-devised underplot amuses readers. Devise a believable and effective underplot after you have comprehended the flow of the story. If you form an underplot with mere ideas, without considering the comprehensive structure of the entire story, the story becomes awkward.

Final Stage

Creators often think about the story theme based on the type of story and characters he or she wants to create, but he or she should place top priority on the creation of an attractive plot and synopsis while considering the story structure or organization of ideas.

When you have created a strong plot and synopsis, think about formulating the subject theme as well. Allow each character to have a subject theme, or let your characters possess opposing themes. Utilize the methods described in this section in order to complete your story and to draw an attractive manga.

An attractive manga or novel requires a story with a convincing introduction and a technique that allows readers to read it without pause. Daily writing practice will enable you to create a story that can be enjoyed to the end in a nice and smooth flow.

Setting Up and Creatin[g

The manga world requires a defined structure. There are two factors to consider in this process: the illustration and the story.

What Is a Manga World?

In the world of manga, animation, or illustration, the concept of a "manga world" does not merely refer to any specific world. Rather, it can pertain to a world setting, character design, background, lifestyle, and any other elements. The manga world gives you a realistic impression of a created world.

Your manga world should persuade and attract other people to your fictional world. The following section presents the methods for constructing a manga world from a picture.

What Types of Works Express a Manga World?

In the world of art, there are various media you can use to construct a manga world, such as cartoon, animation, illustration, game art, and more. To attract people into your fictional world, your creation has to be as specific as possible because what one sees is perceived as it is—unlike music, for instance, which tries to express a foreign world in an abstract manner. For example, in a work that depicts the story of a school life, you need to construct details, such as the characters, clothing, design of school buildings, and other elements—unless the work is a documentary or a

completely fictional piece. This process is the creation of a manga world.

Unless you want to purposely create a vague manga world, the information of your manga world should be presented as explicitly as possible. It should be abundant and specific, without exaggerating the background, lifestyles, small objects, and characters. The scenery should be illustrated in an appropriate manner so as to welcome readers into your world without hesitation.

In order to create a convincing illustration, you should design the background world, small objects, lifestyle, and other elements thoroughly. For instance, in games or animation, the detailed parts of a minute object or a building are normally defined in a precise manner. Animation or game art is successful when it possesses a clearly defined and united world.

In creating cartoons, the artist alone constructs the manga world, and his abilities are reflected directly in his power to attract readers into this world. For example, if you want to create an ambiguous world, your illustration needs to posses certain elements that are powerful enough to attract readers to your work and override the sense of ambiguity.

An illustration can express many things, but it will not touch people's hearts unless it conveys the story's message and concept to the viewers. What is drawn and expressed in an illustration is the essence of a manga world. Experiment with various compositions and expressions in your art to transmit your desired message.

Representational Design

There is a technique that gives representational meaning to the motif or theme of your illustration. This technique requires you to express all your ideas on one sheet of paper.

For instance, the sun represents glory, light, warmth, and the origin of life, and is given the absolute power equivalent to that of God's. It carries a bright image, and is drawn in contrast to darkness and night. Another example of a representational motif is a serpent, which gives an image of deceitfulness and represents ritual and spiritual aspects. Sometimes, it implies infinity and the universe.

By positioning the motifs of these representational images effectively in your work, viewers will be able to grasp the concept of your illustration, which assists in intensifying the image in your manga world.

Some symbolic motifs that can be incorporated into your illustration are: a snake, flowers, or other natural elements, such as the sun, sea, and sky.

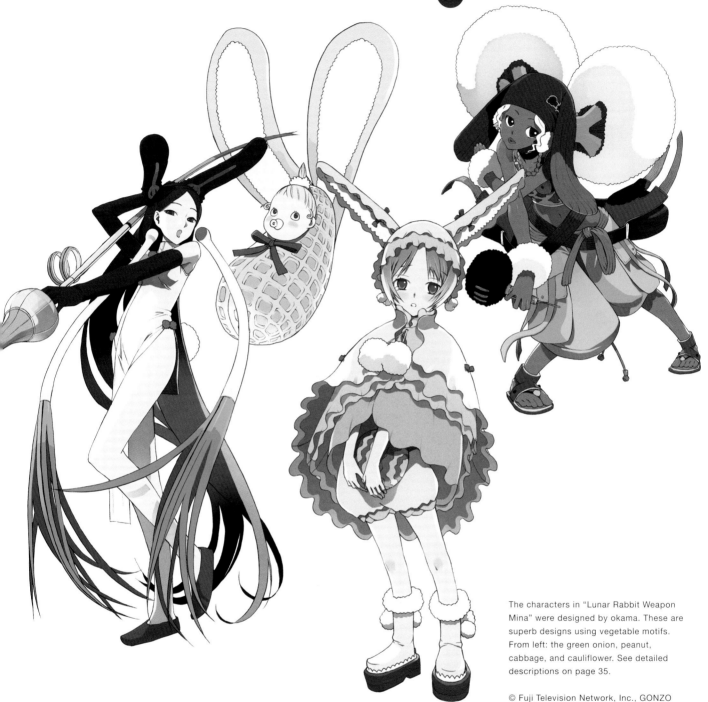

The characters in "Lunar Rabbit Weapon Mina" were designed by okama. These are superb designs using vegetable motifs. From left: the green onion, peanut, cabbage, and cauliflower. See detailed descriptions on page 35.

© Fuji Television Network, Inc., GONZO

Think about the impact of concepts, such as strong masculinity, tender femininity, coldness, warmth, and so on—then, you will be able to recognize the importance of assigning representational motifs to your characters, their background world, and objects.

Character Design

The character's specific hairstyle, clothing, and facial gestures are important elements in describing his or her personality.

You can also express the manga world by presenting characters in recognizable themes—for instance, realistic or unrealistic, Japanese style,

Medieval European, SF, comical, and others. You can attract viewers into your art world by displaying characters with these familiar attributes.

Numerous drawings are required, though, to create a manga world that is different from the world as we know it, since you want to present a completely original setting.

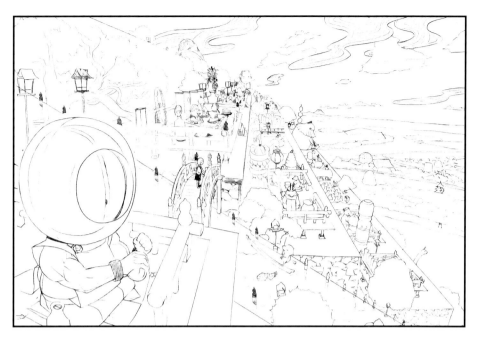

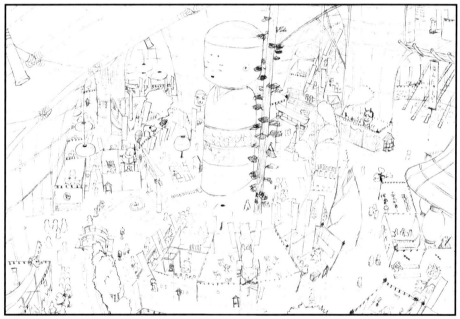

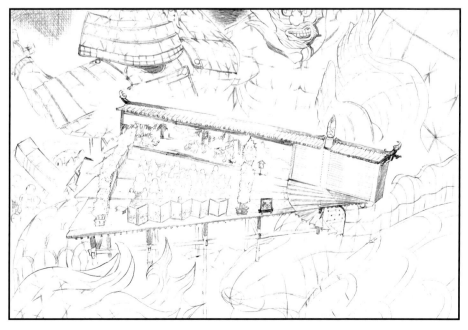

Animation backgrounds and image
illustrations designed by okama. We can feel
another world in every detail of his
illustrations, which attract viewers
immediately to these scenes.
From top to bottom frame: "Kamichu!"
Bottom: "The Wings of Rean"
See pages 22-39 for more of okama's
designs.

© SUNRISE, BANDAI VISUAL CO.,LTD.,
BANDAI CHANNEL CO., LTD.
© Besame Mucho, Aniplex Inc.

Background Designs

The background of an artwork is an important platform for the manifestation of a manga world. The key to attracting viewers into the world of illustration is being able to express reality in the background. The setting does not have to be a complete mirror of the real world, but should show the general atmosphere, type of people who live there, and their way of life. You can portray the background totally from your own creation, unless you choose to draw an actual landscape. It's essential to prepare the best platform for the characters in your work.

When you draw a background, colors and shapes of objects play important roles as background components. These days, it is not surprising to see characters with unrealistic red or green hair due to the influence of animation and other media. However, if you see a green sky or a scarlet ocean in the background, you will immediately feel that they are not parts of a normal world.

Try to construct your own world of illustration using a variety of elements.

Your artwork has to convey your intended thoughts to the viewers, so the background is considered to be one of the most important design considerations. It should not be left uncolored unless it is intentional, because it is not only abstract, but also representational, and can transmit the impression of a drawing eloquently. For example, a bright blue background gives a fresh impression, whereas a solid black background can give a feeling of oppression or darkness. You can add more colors or techniques, such as a gradation or blot, in order to expand your range of expressions.

Designs of Small Objects and Lifestyles

Small objects, characters' lifestyles, and the time period represented in your work constitute the important elements for describing a manga world. The detailed work of the small parts can increase the reality in your illustration. However, if you neglect such details, defects in your drawing can stand out, especially if your characters are drawn vividly.

Since small objects and characters' lifestyles are closely related to the setting of the entire manga world, they should be drawn in a manner that allows viewers to feel them by just looking at them. Viewers should be able to grasp how the characters live, although the everyday life is not drawn clearly. It is also important to create a world that maintains consistency in the background setting, characters' clothes, hairstyle, and other elements.

The designs of small objects and lifestyles can be applied further to product designs and the creation of new characters, even if they are not developed into goods or merchandise. The more tools you use in your tool box, the wider your range of expression is of the manga world in your illustration.

Manga World Expressed in a Story

Unless you use a medium, such as a novel or music, that does not show concrete elements to the viewers, the expression of a manga world becomes visual. However, you should not forget that one of the important elements in attracting people to the world of your artwork is to express your world in relation to the story. A common method for this is to incorporate the elements into the story's setting, rather than to describe the world itself. However, people will not be able to enjoy your work if they cannot feel the reality in it; they will only grasp a fictional world.

An artwork that does not exude conviction shows that the creator does not have enough comprehension of the world of his or her own work. If you leave the details of your story unclear, the story becomes incoherent, or the world loses its identification.

Presenting your manga world to the viewers means to construct not only fictional settings, but also to indicate how "naturally" the characters can live in that world, and how they look at the world from their point of view.

If such a world functions well, the reader, viewer, or user is able to connect with it—he or she can breathe the same air as the characters, and be able to open his or her wings of imagination freely. An artwork with a good manga world should be able to make many people share their emotions by feeling the world. They should be able to access to the world more actively. Today, people enjoy sharing the same world of their works through the Internet. In the world of virtual reality, people carry on a conversation with others as though they live a mutually created world. We could not have imagined such a world in the past, but now the Internet has become a necessity in creating an elaborate manga world.

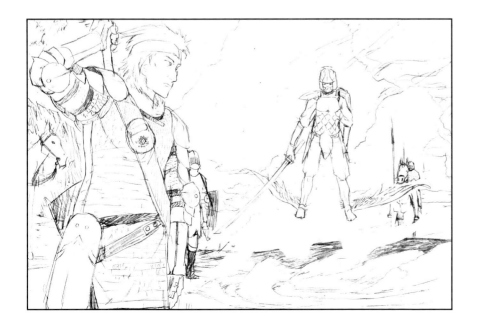

How to Present You

These three sea scenes can express significantly different images depending on how you draw them. Try to express the atmosphere of your world by drawing in different ways.

The impressions of the three landscapes vary significantly when you use different colors in the sky and the sea. One sheet of illustration can give a different impression depending on the first glimpse. Color plays a great role in the composition of an illustration.

Manga World

Professional artists express their ideas in various ways. How does one begin creating a manga world?

Express originality

Originality is not a virtue that can be attained forcibly. Nor should it be created by imitating other works. When a manga is created based on your own idea, that work is original.

A creator relates an image to an object, which is formed as a mixture of multiple elements. For example, if several creators are asked to draw a girl with short hair as a subject, they should be able to create many designs that fit such a description. It is impossible for each creator to draw exactly the same picture as the others. Each should illustrate a different image about the girl's short hair and facial features that match each individual hairstyle.

This theory also applies to writing stories. For example, for a story about a knight and a girl who go on a journey, it is possible to create many story patterns by changing a few elements in the story, such as the personalities, purpose of the journey, stages, era, and so on.

Traditional subjects, such as a quiet little girl wearing glasses, or an angel who grants wishes, and so on, can retain their originality by adding creative elements of your own. If you have a wide range of ideas that consist of additional elements, you can develop varied themes in your world of manga.

Have a Wide Range of Ideas

One way to express originality in your drawing is to devise creativity in your designs. You can combine different motifs in the characters, machines, accessories, backgrounds, and other elements. You can find flowers, animals, or insects among frequently used motifs (e.g., designs by okama as shown on page 9, using vegetables as motifs).

You may also incorporate special features of different countries, such as Japanese, Chinese, and other ethnic groups, or you can apply elements from different eras, such as the antiquity, or the Middle Ages. It is possible to combine more than two features. Creativity expands the horizon of your sense of originality. When it is clearly expressed in your work, your manga world will surface more clearly.

What procedures should you follow to expand your horizon of originality? To have many ideas, you should experience many aspects in life. You cannot draw an illustration of the Middle Ages without knowing about it. If you have never seen an SF film or read an SF novel, you cannot draw science fiction. However, when you incorporate these elements into the setting, you risk illustrating an unrealistic impression.

Consequently, the more works you see and experience regardless of the media, the deeper and wider your range of ideas becomes. You may want to take down notes and draw sketches as an inventory for your ideas so you can use them later for reference. These measures help to create your own sense of originality.

Victorian design that shows the use of a period setting. (illustration by Koto)

Combination of a girl and a machine as popular subjects done on Mac G5. (illustration by Mine Yoshizaki)

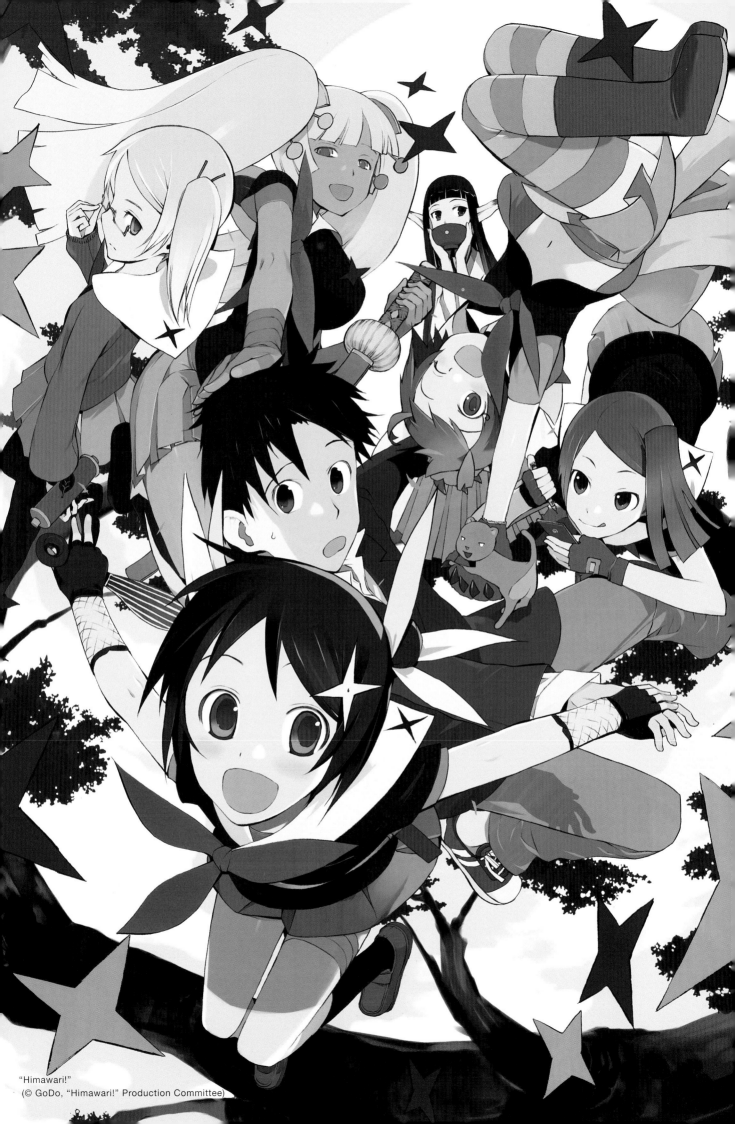

"Himawari!"
(© GoDo, "Himawari!" Production Committee)

okama
おかま





Interview: okama

Born, May 25, 1974. Manga artist and illustrator. After working for a video game company, okama debuted as a professional manga artist. His major works include "CLOTH ROAD" (original writer: Hideyuki Kurata, Shueisha), "Food Girls" (Enterbrain), "CAT'S WORLD" (Kadokawa), Drawing Collection "OKAMAX" (Wanimagazine), and more. He is also a multicreator who has produced animations, such as "Himawari!" (original planner of characters and production designer), "Glass Fleet" (original planner of character designs), "The Wings of Rean" (visual conceptor), "Kamichu!" (production designer), and others.

http://okama.nicomi.com/

About "CLOTH ROAD"

— "CLOTH ROAD" maintains a good tempo, and has evolved quite rapidly in the animation world. Yet, many people thought its progress would take a bit longer.

It will continue to progress. I know I should finish the setting, at least, but I had been too busy. I wish I could spend more time on battle scenes, but I guess the current setting is the best I can do because I am not supposed to spare more pages beyond the schedule.

— What about the story? Do you receive complete chapters from Mr. Kurata, the original writer? Or, do you make any suggestions from your side?

Mr. Kurata gives me the complete scenarios including the dialogues. I just make the settings for the costumes' fashion brands.

— The manga world in this work is very unique. If another person had worked on this cartoon, it would have appeared more ordinary. Here, people can feel your unique and interesting manga world. The power of your drawing is immense. Do you have any particular point that you pay attention to when drawing a picture or when designing?

I work very hard to show the differences among the costumes' fashion brands, and draw pictures carefully so they can be easily understood.

— Many people are impressed with your expression of battle scenes, which makes the pages look small despite the wide scope of your picture. The spatial organization and people's recognition of your drawings are very unique.

Is that so? I don't apply perspective so much. I determine the spatial composition of battle scenes by feeling. I draw town views considering the width and other dimensions of buildings, coffee shops, and houses.

— The story of this work is about clothing. How did you come up with the designs?

I have always thought that Royal Castrato is Gothic and Lolita style; Nike is sporty; Seira is Japanese style; and so on.

— Did you enjoy making different clothings?

It was hard. There were restrictions for the costumes' fashion brands. For the commoners' clothes, I took models after Gothic and Lolita, punk fashion, and others. For example, the theme of May-sama's clothes is flowers, but I drew so many kinds of them that they all looked the same, so that was difficult.

"CLOTH ROAD" (Original writer: Hideyuki Kurata, Shueisha)

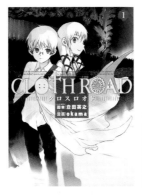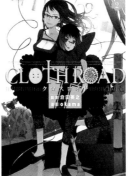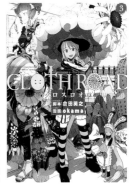

This animation is serialized in Shueisha's magazine, *Ultra Jump*. Since April 2006, it has been published in 3 volumes. Thanks to computer miniaturization and the expansion of technological development, cables have become like thread, and semiconductor chips have become thinner than a sheet of paper. Consequently, computers have become like clothes.

The twin sister and brother, Jennifer and Fergus, were separated from their parents when they were little. Fergus, an apprentice designer, meets Jennifer again and decides to participate in a ring battle called "WAR-KING" with her as a model. After the battle, the two siblings obtain a piece of cloth, which turns out to be a clue to the whereabouts of their parents. They set out on a journey, and arrive at Royal Castrato, one of the top fashion brands, but...

©Shueisha ©HIDEYUKI KURATA 2006 ©okama 2006 ©STUDIO ORPHEE 2006

okama
おかま

— What flower did you use as a reference?

I referred to some books on bouquets. The flowers were all in clusters, so it was difficult to find out their particular features.

— That's interesting. Do you often get ideas from real flowers or objects rather than from other drawings?

Yes, I do. If I look at a piece of cloth when drawing a picture, I draw the same cloth.

— Is there anything you would have wanted to try, or other particular method you would have wanted to use in CLOTH ROAD?

The story develops with various fashion brands, so I would have wanted to show that particular world and the costume style.

— Does Mr. Kurata let you know about the upcoming episodes?

They are roughly set, more or less. I think in the next episode, the characters will visit towers.

— Indeed, it will be interesting to see a new world through the sequels. The story has changed so much from the past episodes. Is there going to be a journey where the characters search for the future?

Yes, they will look for their father, and Fergus will remain depressed. I wonder how their emotional motivation for the journey will change. Mr. Kurata will think about this.

— Are Mr. Kurata's scenarios detailed?

Yes. All the scripts are incorporated.

— Do you create the manga world with these materials?

That's right. The background, clothes, and other elements will create the manga world.

— Do you make any requests to Mr. Kurata? For example, you want to draw certain elements, or you want him to do certain things.

When I have any request, I always let him know. Most of the time, he heeds them. In the case of "CLOTH ROAD," I was able to do whatever I liked, so I enjoyed that privilege. I'm busy, but the work is very exciting because I do manga as well as animation.

"Himawari!"

— I heard that you were involved in "Himawari!" from its planning stage.

The character setting was determined to be ninjas. I set up the characters, and other strange ones.

— Creating characters leads to the creation of a manga world—does that happen?

That's very likely. But usually, people care only about the characters, don't they?

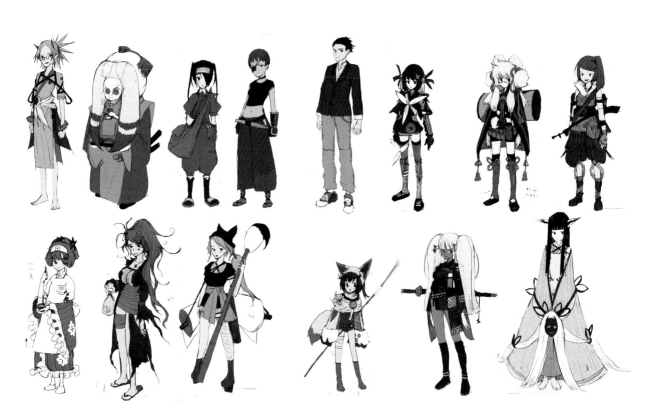

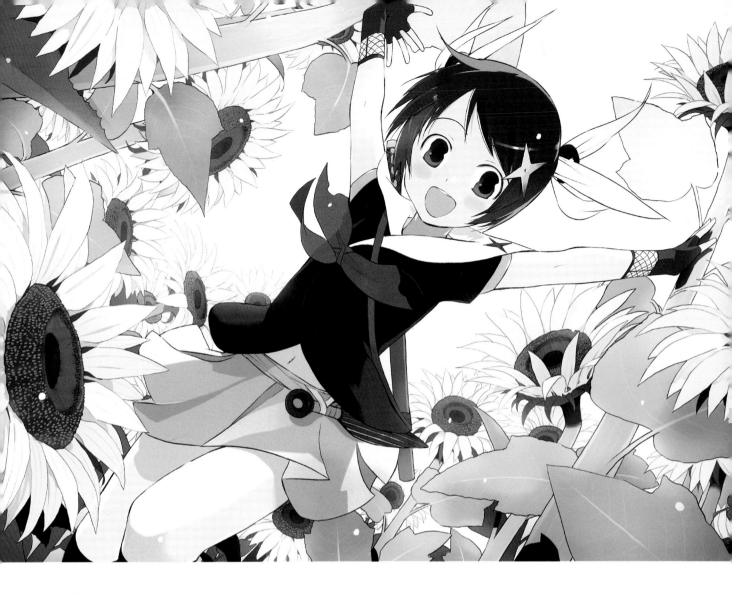

"Himawari!"

"Himawari!!" is an animation directed by Mr. Shigenori Kageyama that focuses on a ninja high school girl. okama has been engaged in this animation from the planning stage. The animation is fun to view, and audiences can enjoy cheerful Japanese scenes and unique, beautiful female ninjas.

Elite girls from all over the country gather in this private "Kuno" training school, the Shinobi Institute, to become "kunoichi" called "Kunos" or female ninjas. They train vigorously in this school every day. Himawari Hinata is one of the Kuno trainees, and a new teacher, Mr. Hayato has rescued her. Himawari meets with her unique classmates at Shinobi Institute, then she…

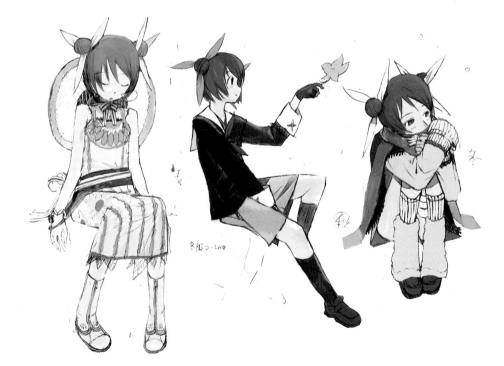

©GoDo/"Himawari!" Production Committee

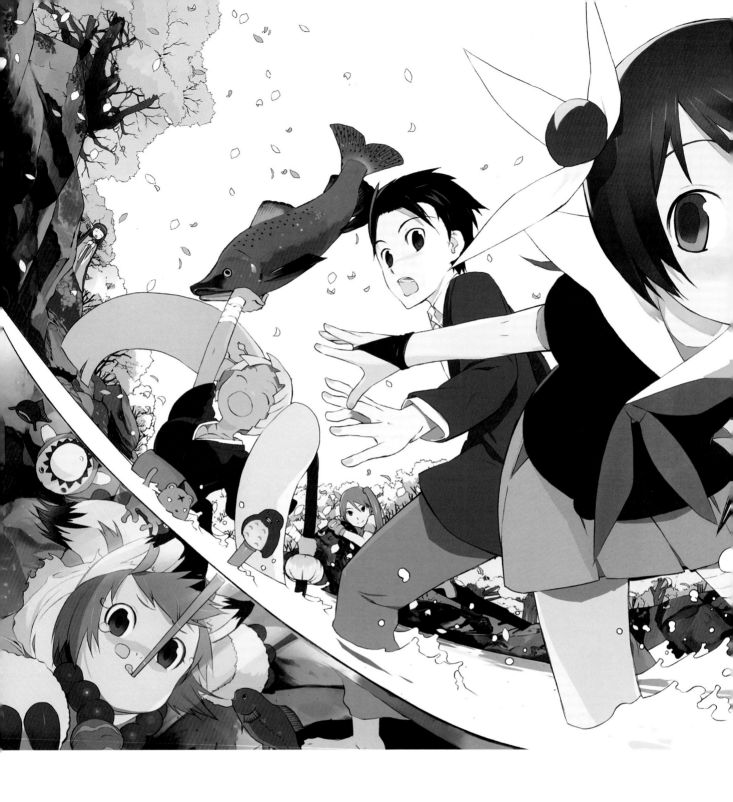

©GoDo/"Himawari!" Production Committee

okama
おかま

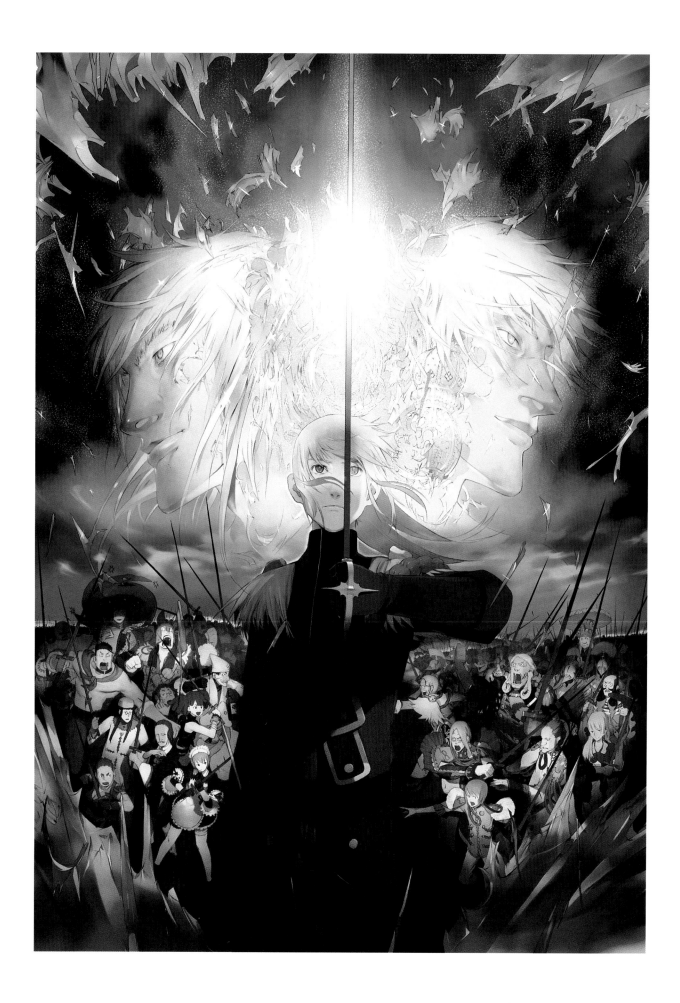

"Glass Fleet"

— Your drawings of "Glass Fleet" are very impressive. They have a different drawing style compared with other creators. Were you given any drawing request or instruction?

It was requested that I draw more adult-like pictures than usual.

— Were there stricter restrictions for creating a manga world setting?

I was asked to set it with an image of a rococo style.

— That means a gaudy decorative image. When a manga world is clearly defined as in this case, you think of images that follow the concept. Is that right?

That's right. I just tried to make it appear gaudy.

"Glass Fleet"

The dignified battleships designed by Mr. Shoji Kawamori and Mr. Kazutaka Miyatake are expressed in 3-D. There are over 80 characters in this work that represent all sorts of styles: military, Gothic style, room attendants, and so on. You can see okama's true talent in these works.

Human beings live in citylike space battleships, called territory fleet, which resemble colonies. They fight over the territories or battleships repeatedly for the purpose of showing off their authority. The People's Army, led by Michel, rose up against the rule of Holy Emperor Vetti, and it was Creo's Glass Ship that saved Michel in the battle.

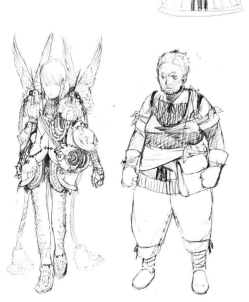

©GONZO/"Glass Fleet" Production Committee

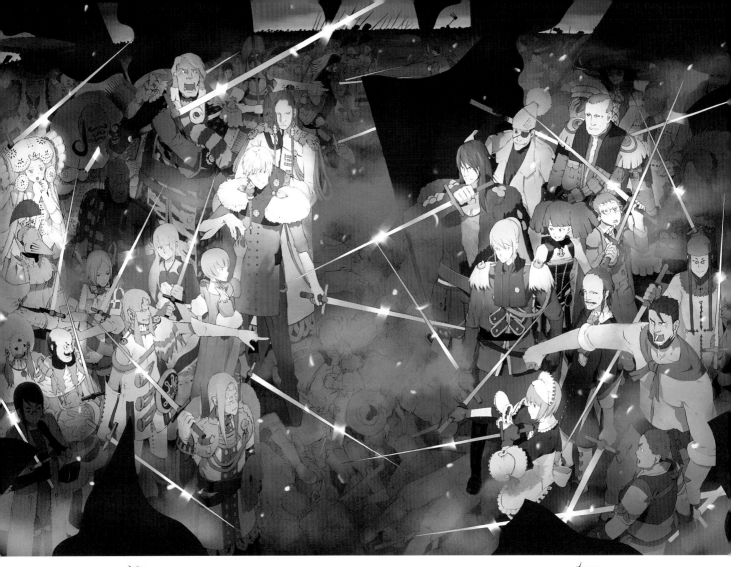

©GONZO/"Glass Fleet" Production Committee

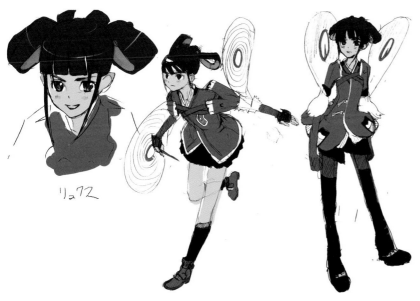

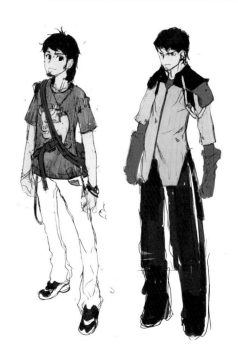

©SUNRISE, BANDAI VISUAL CO., LTD., BANDAI CHANNEL CO., LTD.

"The Wings of Rean"

— There is an older animation called "Aura Battler Dunbine" that is related to "The Wings of Rean." Director Tomino considered Byston Well as a very important world and used its setting in his various works. Was there any point that you paid attention to or any special thought you had in mind when you were designing this work?

I heard that Byston Well was dominated by Japanese people and it was a mysterious world, so while drawing I imagined many reflections of Japanese mentality to make the world look closer to Japan.

— "The Wings of Rean" was very impressive due to the powerful illustrations of Mr. Tomonori Kogawa. In addition, the main character, Shinjiro Sakomizu, is a commando, right? His bony body makes a strong impression.

I drew Sakomizu while imitating the cover I found on the Internet.

— There are also similar characters like Jacoba Aon.

I drew them randomly because I didn't remember their characters. I just heard the name, but I think it's not the same Jacoba Aon in "Dunbine."

— Is there any other design apart from the Japanese style that you want to experiment with?

Maybe combining an insect and the Japanese style. I used such combination in the design of the armors and other elements. I didn't think clothes were very distinctive in "Dunbine." Other than skulls, the characters seemed to wear tights from head to toe, so I thought I didn't really have to care much about the clothes.

— Did you try to express different styles from various countries?

I wanted to make the enemies of Sakomizu not use any standard Japanese style, which would give the people the impression of an old "Dunbine."

Animation designing

— In the world of animation, you need to work on concept designing, original planning of characters, and so on. How do you initialize a design work?

It depends on the project. For example, Mr. Kurata offered me the works of "Kamichu!" and "Gun Sword." Simultaneously, I was drawing illustrations for the covers ("Comic Flapper") at Media Factory, and Director Tomino saw my work and assigned me "The Wings of Rean."

— Director Tomino has a serial comic "King Gainer" in "Comic Flapper," so he must have seen your work there.

Media Factory is involved in the production of "Aquarion," and when Director Tomino was looking for an illustrator, he found me. I got the offer to do "Himawari!" through the serial work, "Maji-Cu."

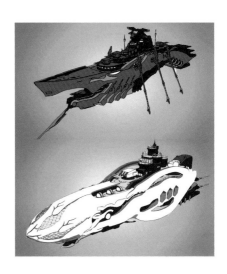

"The Wings of Rean"

Director Yoshiyuki Tomino, who is well known for "Mobile Suit Gundam," was involved in the Japanese TV anime series, "Aura Battler Dunbine." It uniquely combines robots and fantasy. "The Wings of Rean" is the second work found in this world of "Byston Well," which was the stage setting used for "Dunbine." Director Tomino introduced a serial novel with the same title in the magazine, called *Yasei Jidai* (Kadokawa) when "Dunbine" was broadcasted on Japanese TV (now published as one of the Kadokawa Bunko series). Asap Suzuki, a son of intermarriage, is the protagonist, and he meets Luxe Sakomizu, a girl from another world, Byston Well. Later, Asap arrives in Byston Well with Luxe. People call him Aura Battler, and he fights in many battles.

okama
おかま

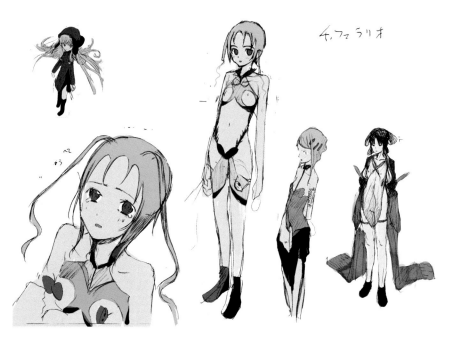

©SUNRISE, BANDAI VISUAL CO., LTD.,
BANDAI CHANNEL CO., LTD.

— So, this serial work is a result of combined connections with people who brought you here.

Yes, it is. You receive an offer if you keep showing your work to the public.

— When you work on visual designs, do you express your image of a manga world in the form of illustration or other similar media?

Many times, the scenarios are already done, so I would be asked to draw a certain layout of particular scenes.

— Do you often do layout designing?

The world of gods in "Kamichu!" has many scenes that used my rough drawing.

— An anime production company may ask you to work for them because most of the time, they like your unique manga world. Do you have any special awareness toward your drawing or your drawing style?

I guess it's my diversity. I don't think there is powerfulness in my drawings. It's not too realistic, either.

— Your works seem to live in a world of imagination or fantasy. Yet, you are also aware of details, and this makes your works look unusually realistic.

Just like manga, isn't it? I understand that production companies now request for ideas of new character forms, so I try to meet that demand.

— Do the keywords in your design concept give ideas for your manga world, or do they extend from words, such as flowers or insects?

I think I often compose keywords from nouns or adjectives. Or, I combine words and describe the fun aspects of the images derived from their combinations. The image I want to give is: to be cool, cute, strong, and so on.

— When you design, are you aware of the viewers?

Yes, I am. The purpose of my work is to transmit my impression. That's design.

— When you design something, is it easier for you if the client has a specific request in your drawing style? Or, do you prefer complete freedom?

I think I prefer freedom.

— Do you have any favorite anime work?

I liked "Kamichu!." The animation was good and the movements were done very well. The background was also drawn beautifully.

Production environment

Machines: PowerMacG5 2G dual, PowerBookG4 500, PowerMacG3 MT266

Software: Photoshop, ComicStudio (mainly line effects), Painter (mainly nozzles)

Line drawing: Mechanical pencil

Cartoon: NIKKO round pen, Zebra G pen

okama: "I don't like G pens, but this is the only tool for me to use in order to draw thicker lines."

"Except for manga, I mostly clean up color illustrations with a mechanical pencil as the pencil line is more expressive. Still, I think pens are better to use for drawing manga. The pencil line can become blurred or rubbed when you draw. In addition, when you want to fill in with bucket tools, the color may also leak, and this is not good for outlines."

"However, digital data can do corrections even if you make mistakes, which make them handy. The quality of your work can be stabilized even when you are mentally weak and are forced to draw a picture."

Works by okama

Animation

"Himawari!": original planner of characters, production designer
"Glass Fleet": original planner of character designs
"Lunar rabbit weapon Mina": original planner of character designs
"The Wings of Rean": visual conceptor
"Gunbuster 2": future visuals, illustrations for final credits
"Kamichu!": production designer
"Gun Sword": design of Brownie
"Genesis of Aquarion": concept designer

Manga

"Megurikuruharu" (Wanimagazine)
"School" (Wanimagazine)
"Hanafuda" (Wanimagazine)
"CAT'S WORLD" (Kadokawa)
"CLOTH ROAD" (Original writer: Hideyuki Kurata, Shueisha)
"Food Girls" (Enterbrain)

Illustrations

"OKAMAX" (Wanimagazine)
"Comic Flapper" (Media Factory): cover
"NewType" (Serial illustrations)

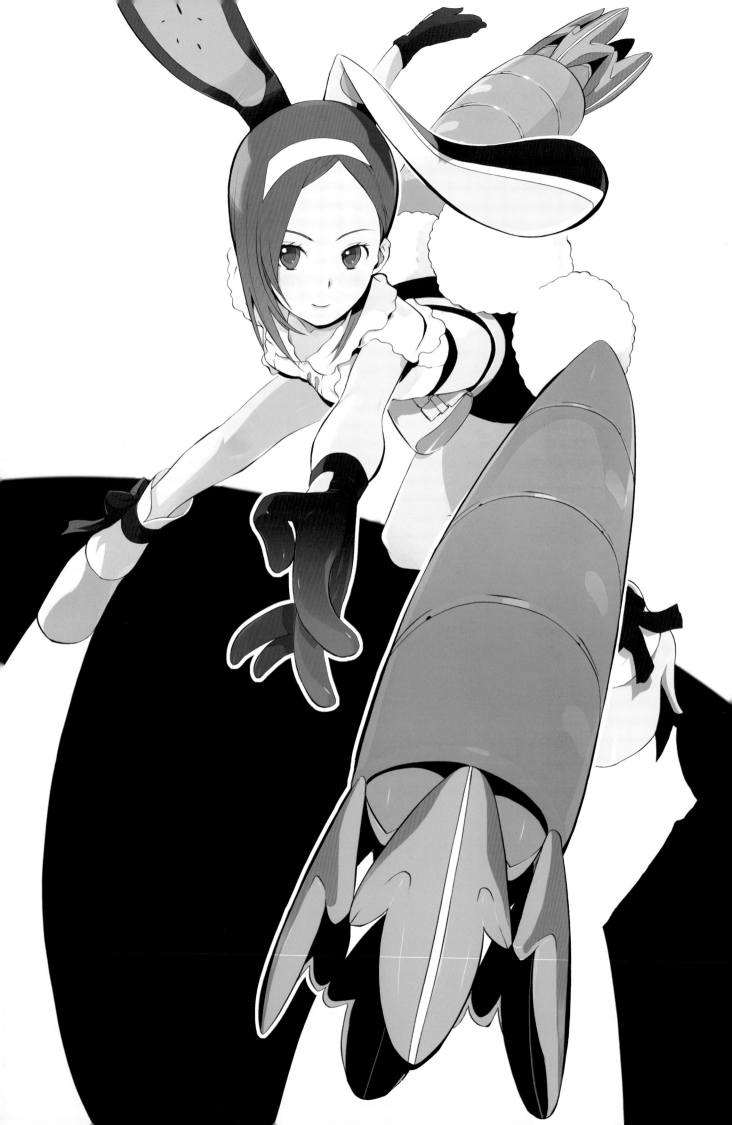

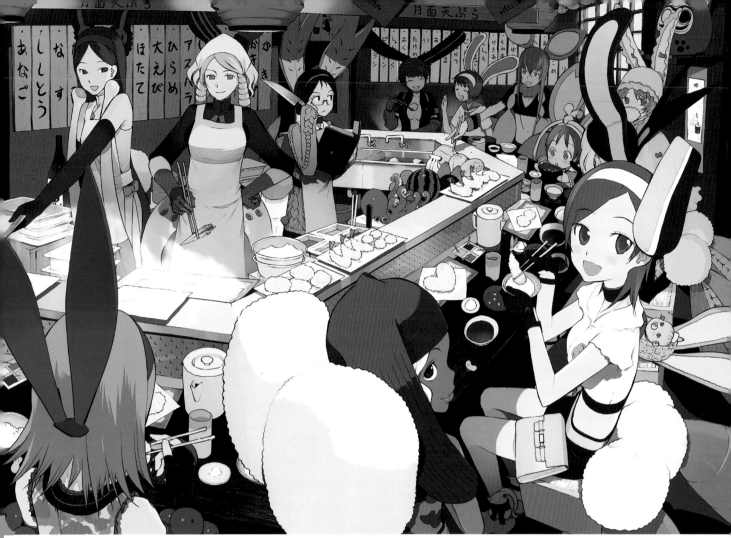

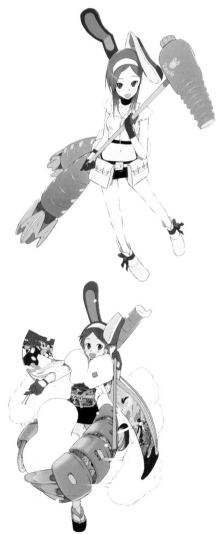

"Lunar rabbit weapon Mina"

OVA project in process

Mina became widely known among non-anime fans when it was used in the opening of a popular Japanese TV drama that described the Akiba-kei, or the Akihabara (Tokyo's electronics district) style geeks. okama's unique characters, which consist of vegetable motifs, represent his excellent designing ability.

okama
おかま

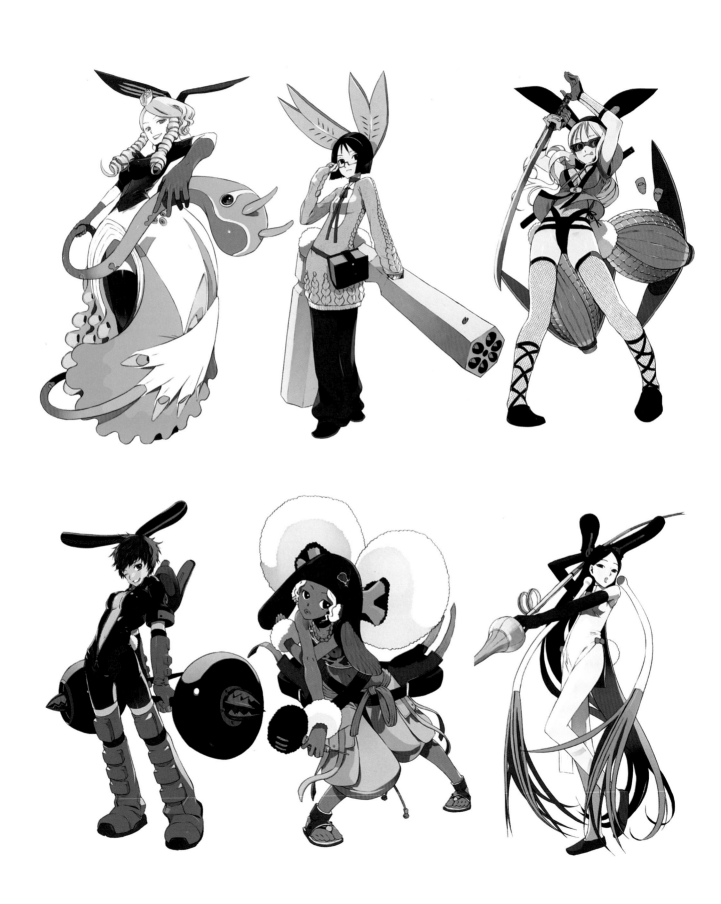

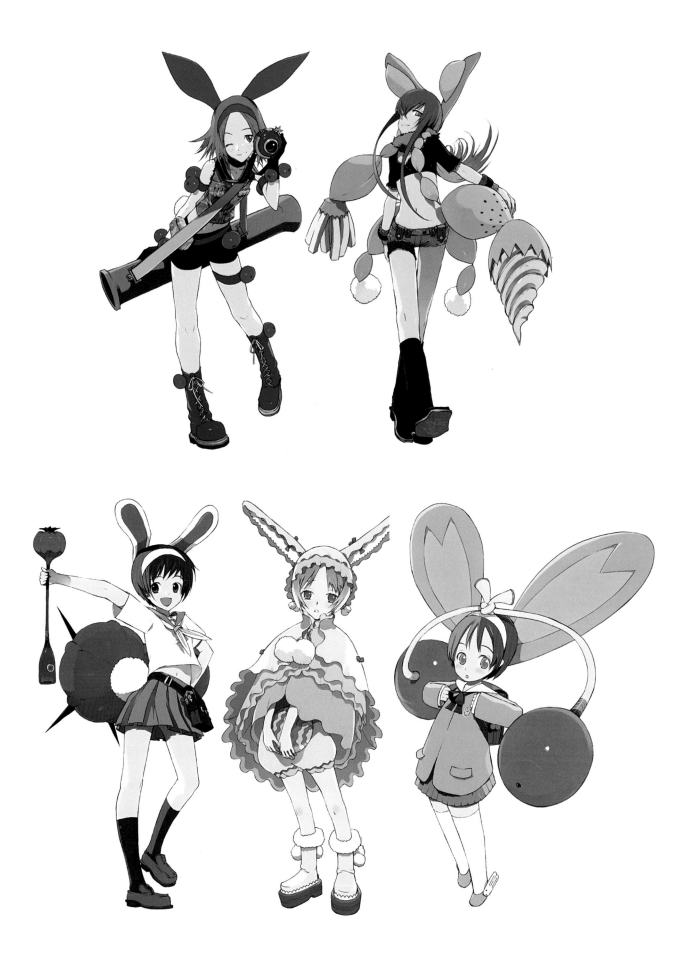

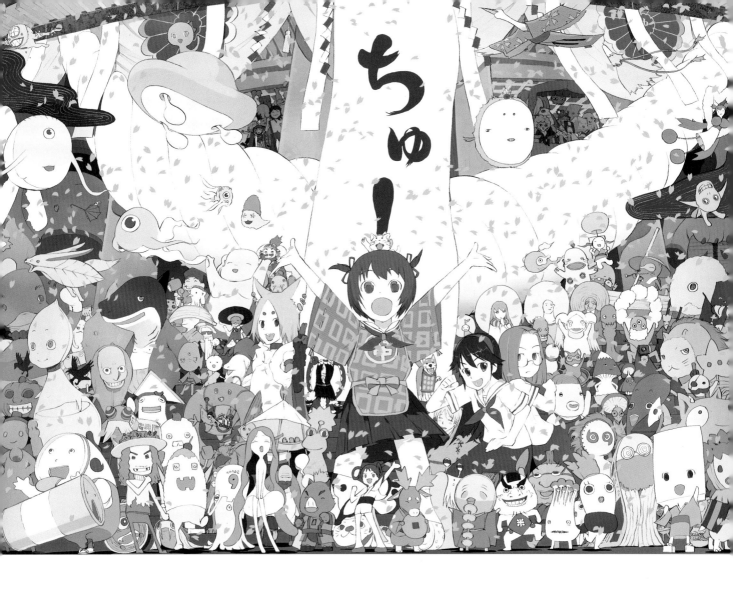

"Kamichu!"

DVD (8 volumes)

"Kamichu!" is an animation that was broadcast on Japanese TV. Its DVD collection includes pre-telecast episodes and are available in stores. okama participated in this manga world setting and in the designs of gods and evil spirits. His strong and unique Japanese influence is fully expressed in his designs, and they project an impression of his mysterious manga world.

Yurie Hitotsubashi was a junior high girl who suddenly became a goddess. She gives guidance to those who need divine power, meets other gods and evil spirits, spends time in the world of gods, and encounters many other mysterious incidents. It is a fun and heart-warming comedy.

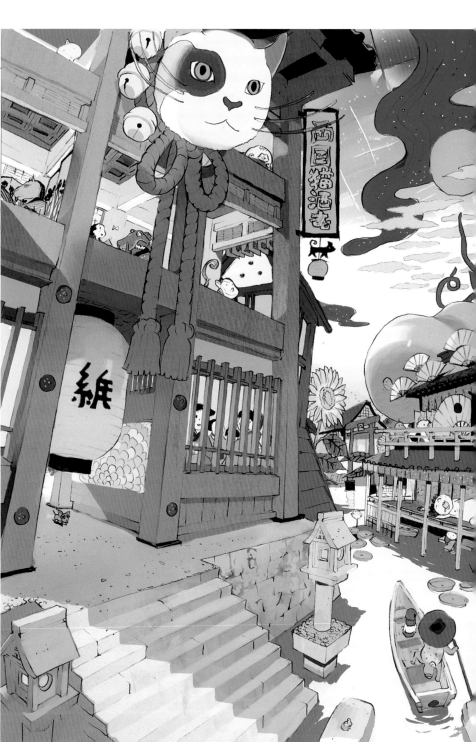

© Besame Mucho, Aniplex Inc.
© Fuji Television Network, Inc., GONZO

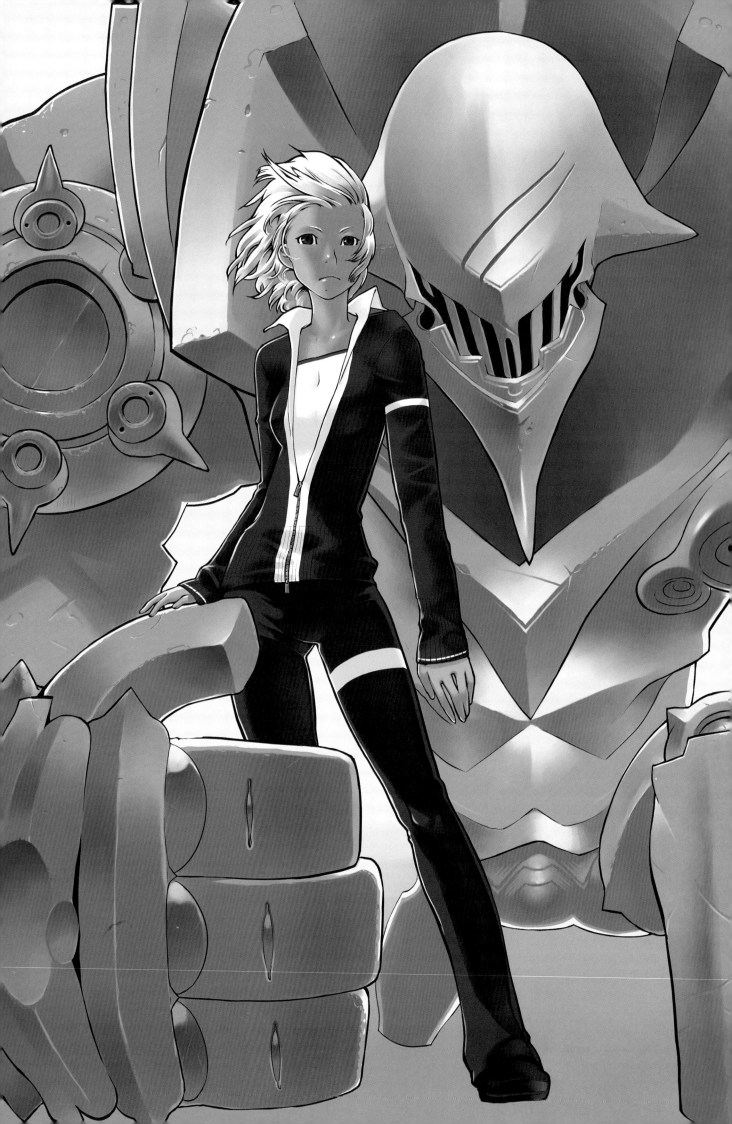

Hiroshi Kaieda

カイエダ ヒロシ

Born, March 7; Hokkaido, Japan. Illustrator for Rocket Studio, Inc., a console game company in Sapporo, Hokkaido. He is also engaged in art settings and character designs for console games. His current manga work is in progress and will be serialized in an upcoming monthly magazine.

© ROCKET STUDIO, Inc.

Interview: Hiroshi Kaieda

— I heard that you are working for a video game company. What is your job like?
My work is to draw illustrations for project proposals, building designs, small objects for video games, and a variety of other drawings. In our company, there is no graphic designer, so we often outsource from designers' studios. Thus, I often talk with the designers and also supervise the designs.

These past years, I have worked on pin-up pages for magazines and many illustrations. I am also writing a manga for a certain publisher. I am so lucky and happy to receive another offer from a different publisher.

— What made you become an illustrator?
I was running a small Web site on a free Web server that was introduced in a PC game review magazine several years ago. Later on, that

"Summons Giant"
From "Comickers Coloring Book Series 1"

Hiroshi: "I started drawing by impulse pieces of armor. I could draw a strictly medieval picture, but I thought it would not be fun, so I decided to add some elements, like a bodyguard. I came up with an idea of using a girl as a boss. As a result, I set up the theme as 'a woman with a large armor unit as a bodyguard.' My colleague has an idea to start a video game project with this design."

magazine offered me an opportunity to draw an illustration, then I received more offers from other companies.

My former workplace was the first place I worked when I entered the video game industry. At that time, I had a hard time because I had little experience in drawing. I guess you get better at drawing if there is a necessity for it, or you can improve if you have the environment and enthusiasm. After high school, I joined the Self-Defense Forces, then I worked for one of the major food companies—a platemaking industry, and finally, I was a part-timer worker at one company where a friend of mine worked. He recommended me to enter this industry. I am really grateful to him.

— Is there any factor that has influenced your creative work or hobby?
I often see movies. I love those with a dark mood, especially the ones that are full of action. I've looked forward to *Underworld Evolution*. I also like pure fantasy movies, such as *The Lord of the Rings* and *The Chronicles of Narnia*.

I play any kind of game—both console and PC, but I tend to keep my eyes on the technical aspect or how the program is run, so I can't purely enjoy playing for a long time.

I am crazy about dogs. And, sometimes I go out to observe people without thinking of anything.

Drawing Materials and Techniques

— What drawing materials do you use?
I hardly have any experience in drawing manually. I have many works on the computer. For software, I use both Painter and Photoshop. I like Painter because it is handy for making adjustments in order to get my desired expressions. The adjustment work becomes more difficult now with the recent versions, though. Photoshop is also indispensable for me because it enables a direct recognition in adjusting colors.

— What is your work flow like?
First, I scribble on Painter, then draw roughly with a liquid crystal tablet. Most of the time, I finish the line drawing and divide it into parts using layers for color adjustment.

The next process is to color. As I pay attention to the base colors, I make fine adjustments, then I transfer my drawing to Photoshop by outputting it as PSD files. After adjusting the colors of each layer, I put the images together and make some final fine adjustments to finish it.

Hiroshi Kaieda
カイエダ ヒロシ

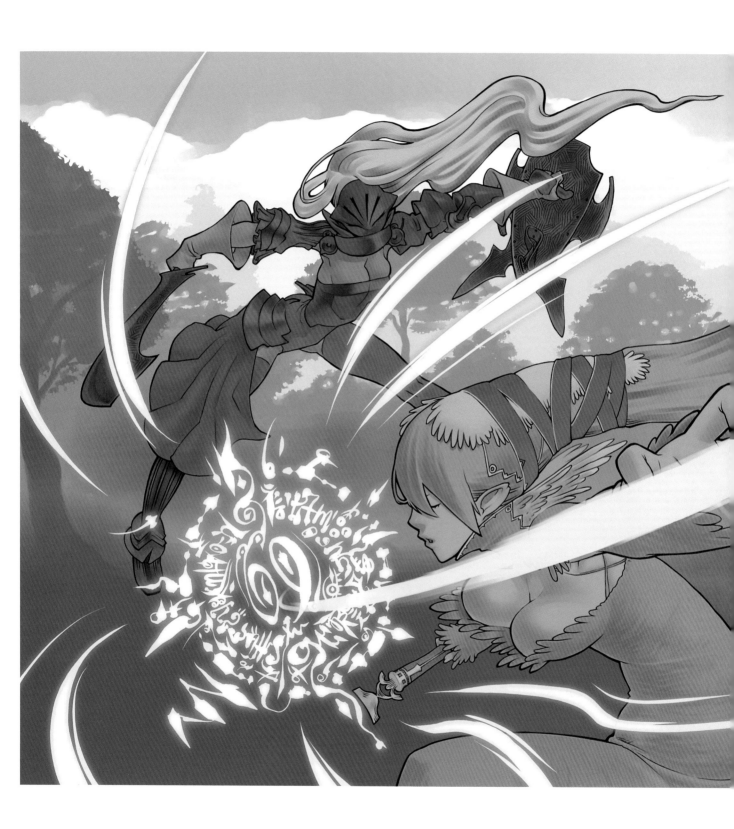

— What do you care about most when you draw an illustration?

The primary point for me is to make a focal point, especially for the colors. I care about showing a woman's body erotically. I think the definition of "eroticism" differs from person to person, but I draw pictures because I believe that eroticism can exist in any kind of picture.

World of Drawings

— When you draw an illustration, how do you expand your imagination? How do you make up a world and express it?

As I mentioned earlier, I believe that a character, whether male or female, should possess eroticism. I think the same is true for inorganic matter in the world of illustration. I'm not talking about sexual connotation. I believe that eroticism exists in a large essence in any illustration. I have many opportunities to draw illustrations mainly with characters, and I emphasize eroticism that the characters may possess.

I also think that it is impossible to incorporate many elements in one sheet of drawing, so I always try to draw one prominent element in my drawing.

— Do you have any message for our readers?

It is not difficult to become a professional artist. The struggle starts from hard work. I am also in the middle of continuing and struggling with many battles, but I hope to see you on that battlefield.

Production environment

Machines: Self-made PC Compatible
OS: Windows XP sp2
CPU: AMD AthlonXP 2600+
Memory: 3 GB
HDD: 80 GB + 120 GB + 300 GB [+ 30 GB + 30 GB mobile rack]
Software: Painter, Photoshop

"AMBROSIA"
From "Comickers Coloring Book Series 1"

Hiroshi: "I borrowed part of the title in an MORPG, which our company started to make but suspended. The original design of this MORPG was more for avid fans, but I finished it using lighter characters. The battle scene with a sword and magical power seemed so orthodox to me that I planned to change the armor scene into a witch scene, but we decided to take the royal road and finished it as shown above. I still find some vagueness in this illustration as I look at it, and have an urge to fix it."

Hiroshi Kaieda
カイエダ ヒロシ

Drawing Models by Hiroshi Kaieda 1

Hiroshi's drawing technique illustrates his stylish and sensual world. He uses the computer entirely, even for his rough sketches.

From Rough to Line Drawing

First, an image is transformed into a concrete shape. While searching for better results, Hiroshi makes adjustments in real time. You should see significant changes as the diagrams progress from rough drawings to a finished product.

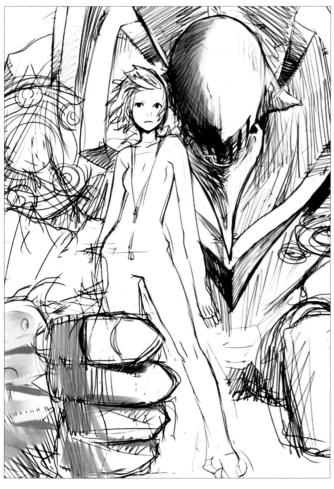

step 1

For the rough drawing, Hiroshi draws the person's figure in a simple manner considering her silhouette, and that of the giant's. He clearly clearly defines the body type.

step 2

Hiroshi makes significant changes in the position and movement of the arms, which make them stand out more, compared to the lines of the rough drawing.

step 3

The vague parts become clearer. In order to show a sturdier image, Hiroshi changes the shapes and the lines of the hands slightly.

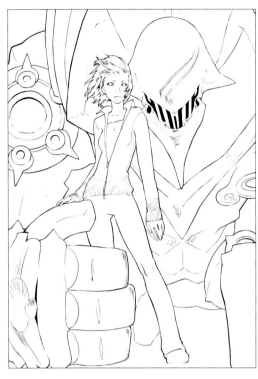

Dividing into Parts

First, Hiroshi determines a different color for each part to facilitate corrections later. This is a technique that can be used in computer graphics only, where it is not a problem to make an error and redo. If you save layers or selected areas for each part, those parts can be restored for additional changes.

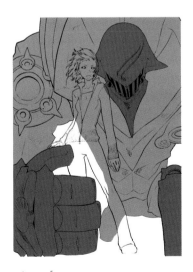

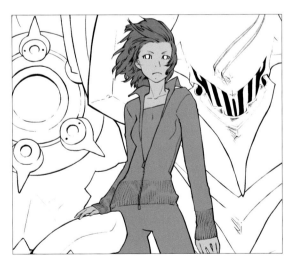

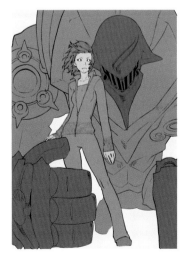

step 4

Hiroshi paints only the giant. It is important to use a different color for each separate part.

step 5

He paints the woman in different colors. Since she uses more colors than the giant, she will also consist of more parts, such as the hair, skin, jersey, inner shirt, and other elements.

step 6

If you save the layers or the selected areas of each part individually, they can be restored for further changes.

Hiroshi Kaieda
カイエダ ヒロシ

Tinting

Hiroshi colors the main character in the center and the background simultaneously. This facilitates the adjustment of a subtle tonal balance in the entire picture.

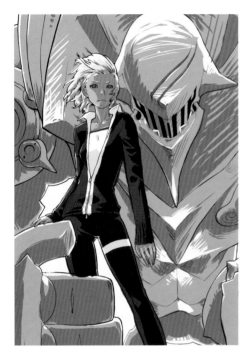

step 7

The picture is painted roughly to determine the color scheme. Then, the overall quality and density are heightened.

step 8

To brush up the giant, Hiroshi stresses the sense of artificiality with a hollow at the back of the hand. His special attention to details, such as the mouth, body design, body scratches, and other parts, brings out a realistic character.

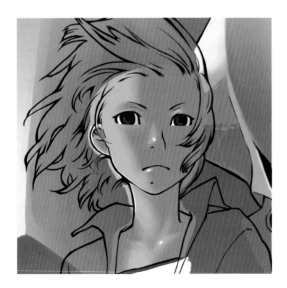

step 9

There are many bumps around the face and the collarbones, so they are drawn with a more delicate touch.

step 10

In painting the clothes, there is a clear division between the colors. Here, the attire appears tight.

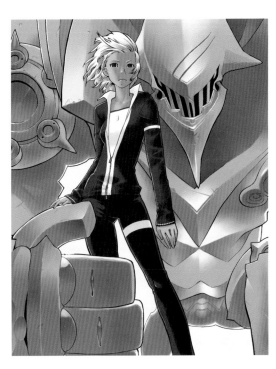

step 11

As he tints further and gradates, the colors become natural.

Finishing Process

While tinting the background, Hiroshi finishes gradually by considering the entire balance. He makes further adjustment with Photoshop after painting.

step 12

Then, he adds a modest tint. He experiments with more green over the colors to create a fantastic atmosphere.

step 13

He adds a reflection of light to the face bumps, such as the hair, nose, the lower part of the eyebrow, and other elements.

step 14

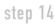

He adjusts the color tones with Photoshop to finish. Here, he extracts the principal lines with a free plugin and adds the color.

Hiroshi Kaieda

カイエダ ヒロシ

Drawing Models by Hiroshi Kaieda 2

This method demonstrates an unusual and remarkable style of digital drawing, in which the process is shortened by making several layers of changes at once. The artist can then focus on the color scheme and tonal balance.

From Rough Drawings to Drawing with Ink

As with Drawing Models 1, Hiroshi starts working on the computer to create a dynamic composition from his unique ideas. The image is almost completed at this stage.

step 1

In this rough drawing Hiroshi's composition has a remarkable expression.

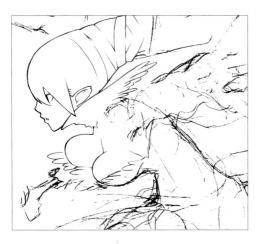
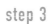

step 2

First, he draws the principal lines on humans. Many rough lines are integrated into one line.

step 3

He works on the details of vague parts. He defines more clearly the handle and the belt wound around her hand.

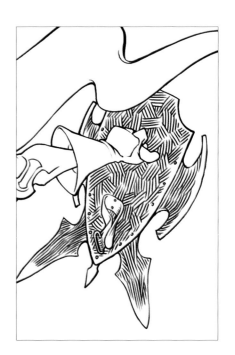

Drawing Shades

Hiroshi draws shades before coloring and makes them 3-D to save on trial and error in the coloring process. This step enables you to concentrate on coloring without having to care much about retouching.

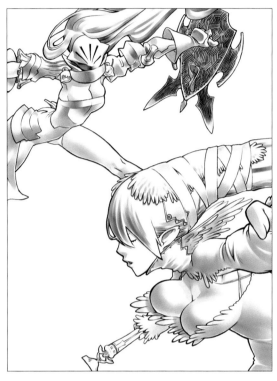

step 4

He draws shades with a monochromatic tone, and also expresses the metallic quality in the armor.

step 5

He paints the bumpy parts very carefully.

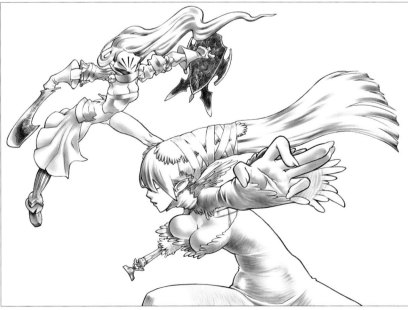

step 6

He paints the dark parts of the shades with a brush or different tones.

Hiroshi Kaieda
カイエダ ヒロシ

Coloring the Background and Humans

First, Hiroshi divides the frame into parts and makes layers for the groundwork. You can save a lot of energy by combining tonal shades and changes in layers.

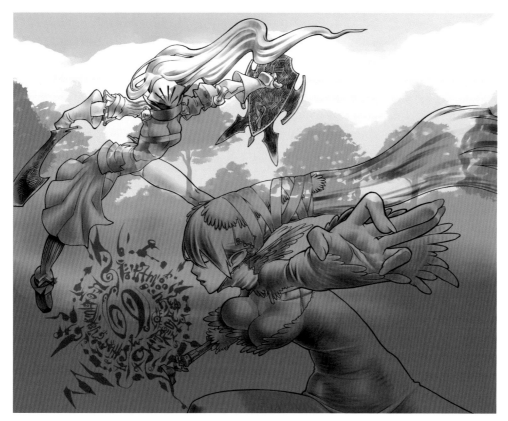

step 7

Then, he works on the background. He starts with the bright parts in the distance, then slowly darkens the tones as he paints closer to the foreground.

step 8

He divides the frame into parts and makes groundwork layers. With this technique, it is possible to finish coloring by laying only a single transparent color over the shades that were previously drawn.

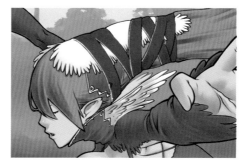

step 9

He chooses a color scheme based on how the underlying shades come out, and how they differ when he changes the status (laying method) of the layer with a single color.

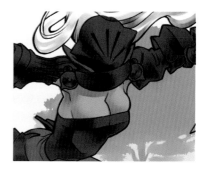

step 10

The technique of creating a metallic quality with a different tone renders impressive results.

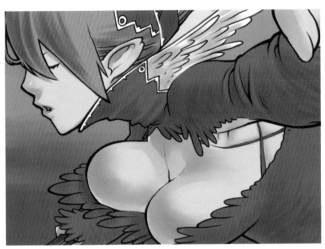

step 11

He works on the breasts and face.
The elaborate touch of shading is
also effective in this picture.

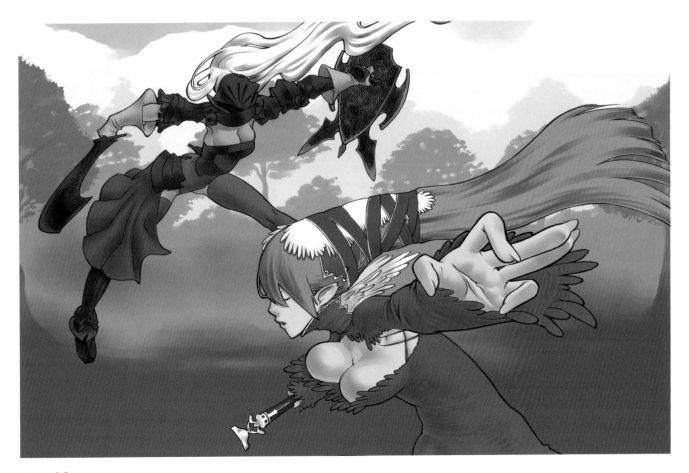

step 12

The coloring is almost complete. He will saturate the colors and blend them
with the background at a later stage. At this point, the humans stand out.

Hiroshi Kaieda
カイエダ ヒロシ

Finishing Touches and Completion

Hiroshi changes the colors of the clothes and adjusts the saturation to make it match the overall mood. Computer graphics is behind this technique, but there are also some parts that are drawn by hand.

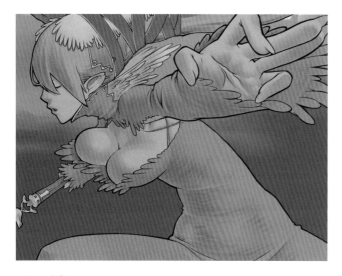

step 13

He adjusts the saturation and matches it with the entire mood. Here, he changes the color of the character's clothes from red to green.

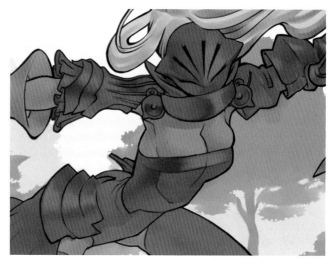

step 14

Hiroshi looks at the entire balance and adds reflections. He adds the magical reflection so that the armor has obtained a more realistic metallic quality.

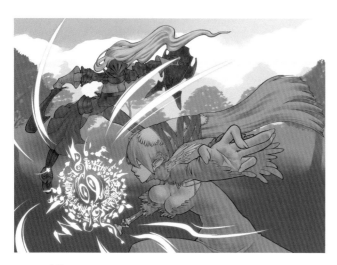

step 15

He adds more colors to the entire picture. The expression of light increases vigor.

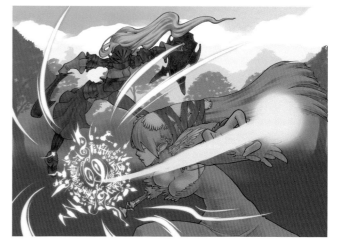

step 16

He adds a magical light that reaches the arm. He makes further adjustments until he is satisfied, and the illustration is complete.

"Ninja Girl z"
From "Comickers Coloring Book Series 1"

Hiroshi: "I have always liked pseudo ninjas, and I often scribble them. When I was offered this work, I first thought this was my opportunity to draw them. I already envisioned them in a monochromatic picture, but I really appreciated having the opportunity to do them in color. It was hard to finish them in quiet colors."

"Ojo Ari!"
From "Comickers Coloring Book Series 1"

Hiroshi: "This is another material that I had abandoned for a long time. The subject of this illustration is an unrestrained daughter of an upperclass family, who makes trouble and bothers her bodyguards and household keepers. I used a color scheme that I do not use normally, but it resulted in an interesting illustration with a typical animated touch."

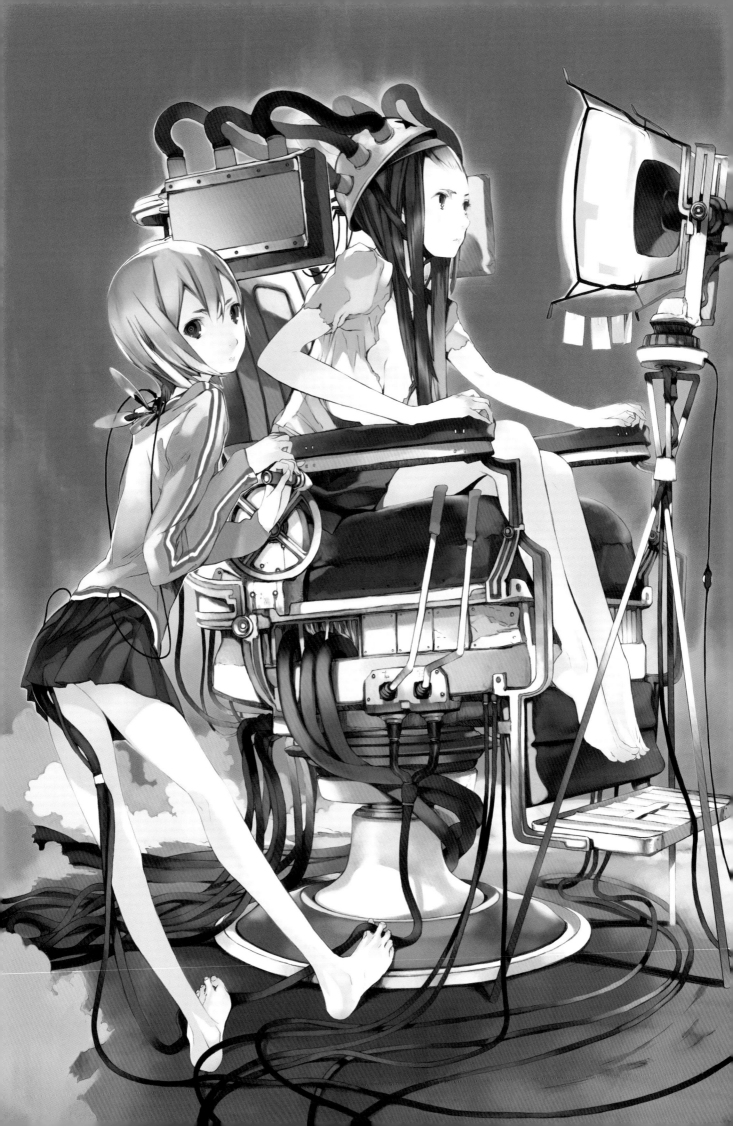

Houden Eizou
放電映像

Born, May 1979. Former illustrator for the magazine *Dengeki hp* (published by MediaWorks). Later, he drew illustrations for various novels, such as *Asobiniikuyo!* (published by Media Factory) and *The Fox Spirit of My House*. He is one of the young illustrators currently in the spotlight.

Drawing Models by Houden Eizou

This section, based on an interview from a recent issue of *Comickers Art Style*, features the step by step drawing methods of Houden Eizou. He uses digital technique but maintains the warmth of an analogue illustration.

Rough Drawing

The illustrations shown on this page are taken from Photoshop Super Techniques. Houden Eizou has expanded his imagination from the digital world.

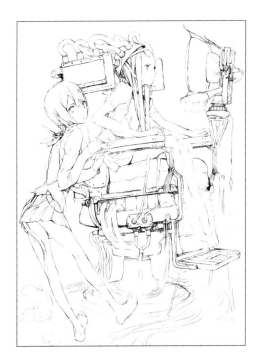

step 1

In this impressive rough drawing, Houden Eizou wants to show two characters, "RGB-ko chan" and "CMYK-ko chan." He creates his own ideas with this goal in mind and shapes the image into a concrete form.

step 2

He cleans up the rough parts, such as the human figures. Then he draws the machine's cords and other small parts.

Houden Eizou
放電映像

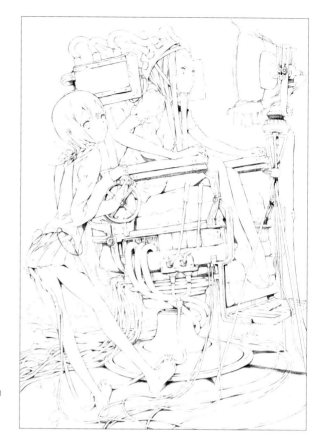

step 3

The line drawing is almost completed. Houden Eizou cares about every single detail and works with extreme caution.

Working with the Computer to Clean Up the Line Drawing

Now, Houden Eizou starts to work on the computer. He cleans up the dust that is captured during scanning. Then he arranges the lines.

step 4

He creates this line drawing on A3 paper (ANSI B size), then he scans it in halves and connects them together. The resolution is set at 600 dpi. If this is too heavy for your drawing, you can also use 400 dpi.

step 5

He positions the lines in different layers and adjusts their levels. Then, he selects areas with the Quick Mask mode, creates new layers, and blackens this part.

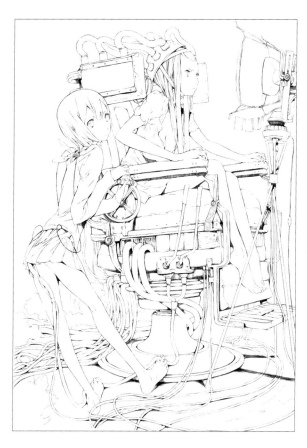

step 6

At this stage, he sets the color mode in CMYK. He does not like the way it is framed, so he rotates it slightly and plots margins simultaneously.

step 7

He draws the cords and other parts that did not fit in the earlier frame. Then he removes the dirty spots.

step 8

The dirt has been removed. He copies the line drawing, then he places a layer on Gaussian blur radius 1.0 to condense the lines slightly. The line drawing is completed.

Making Masks and Setting the Foundation

Using the Quick Mask mode, Houden Eizou separates each part of the drawing into layers and sets a mask over each part. He roughly tints the parts at the same time. At this stage, he sets only the light source and the colors.

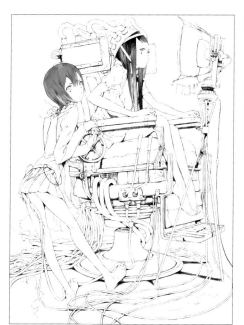

step 9

He layers and masks the hair. He says, "I think Quick Mask is effective for the parts that need to be drawn many times, such as the hair."

Houden Eizou

放電映像

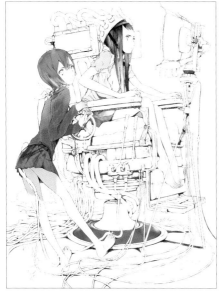
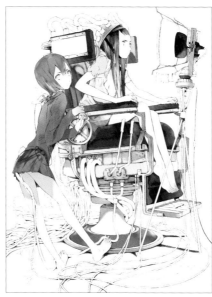
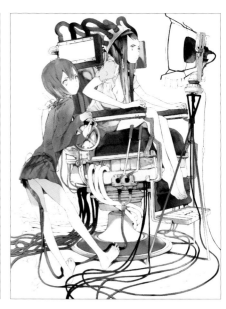

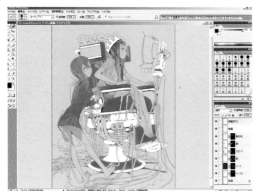

He works on the human figures and the background.

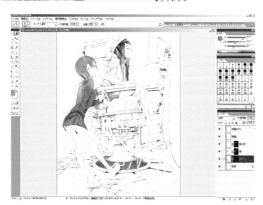

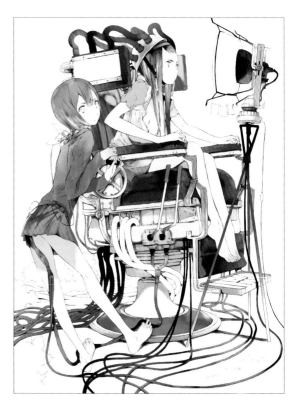

He finishes the masks.

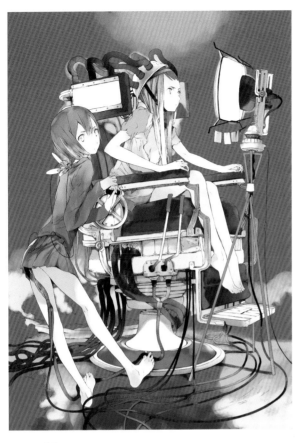

step 12

He colors roughly. "I think a brush with no blurry edge and the flow of 20-30 writes well," he says.

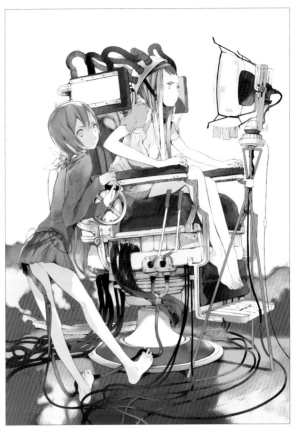

step 13

He changes the background and tries to find the best form, then repeats painting by trial and error.

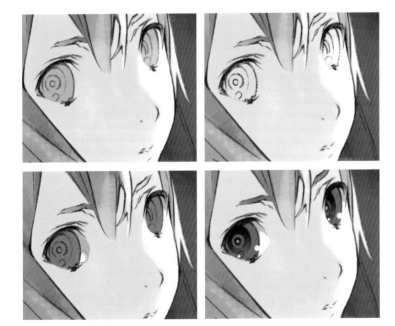

step 14

For the pupils, he makes effective use of masks and uses bold colors to complete the picture.

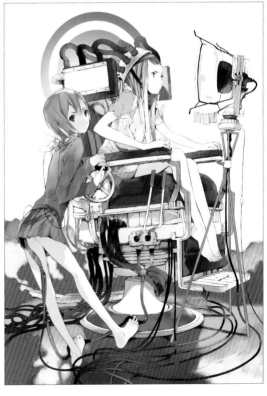

step 15

At this stage, he has finalized the position of the circles in the background.

Houden Eizou

放電映像

Determining Colors

Houden Eizou finalizes the selection of colors as he studies the entire drawing. He uses a 200-sized brush to draw roughly. He does not worry about crossing borderlines because the masks have been created.

step 16

step 17

step 18

You should be able to see the changes made on the clothes, machines, and other small parts. He saves his color choices (see frame #19).

step 19

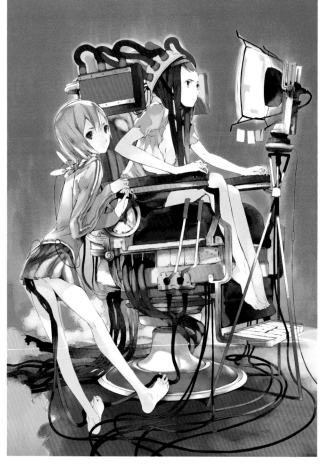

Drawing to Finish

When the drawing direction is set, he begins to draw the details. He carefully works on the roughly painted parts with various brushes and a magnifier.

 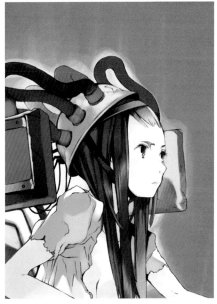

 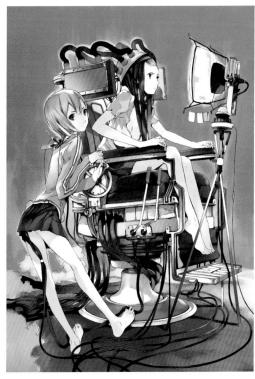

step 20

He shades the details and highlights, and continues drawing.

Houden Eizou
放電映像

He works on the clothes and the skin. Reality and vividness gradually come out in the illustration.

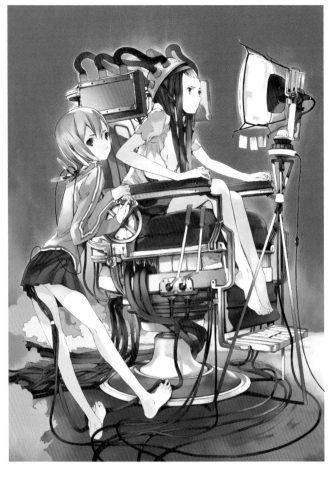

Production environment

Machines: Shop's self-made PC

OS: Windows XP pro sp1

CPU: Pentium 4 3.2G

Memory: 2 GB RAM

HDD: 80 GB + 80 GB + 160 GB
[+ 60 GB + 250 GB external]

Software: Photoshop 7

His first manga Straw is printed in the magazine *robot Vol. 5* (published by Wanimagazine). For more details about this work, see page 12.

Houden Eizou uses a dual display to work more comfortably on the monitor.
The left photo is a screen shot. He works on painting the left screen and displays various information windows on the right so that the monitor screen is fully used.

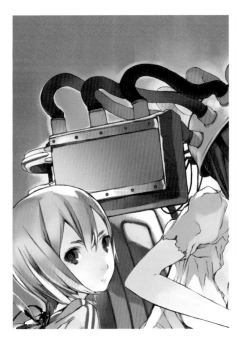

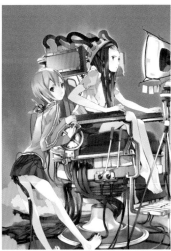

step 22

He changes the tone slightly. The advantage of digital illustration is that adjustments can be made at any step in the process.

step 23

The work is completed.

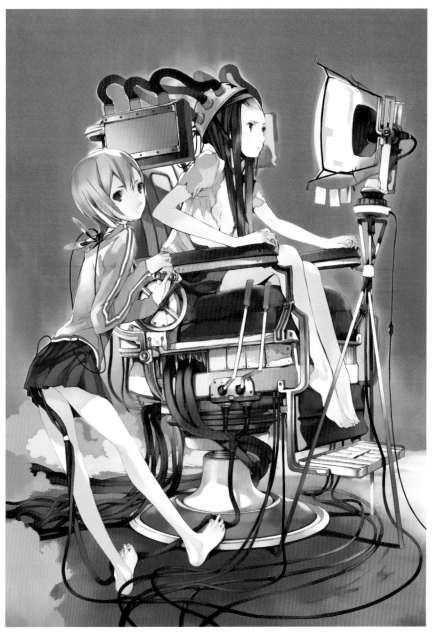

Shigeki Maeshima

前島重機

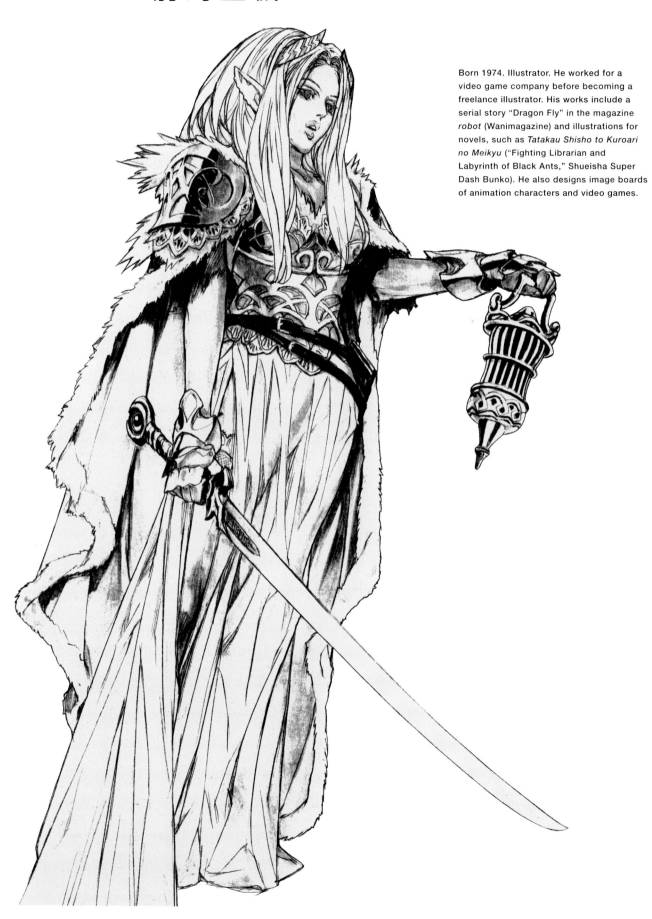

Born 1974. Illustrator. He worked for a video game company before becoming a freelance illustrator. His works include a serial story "Dragon Fly" in the magazine *robot* (Wanimagazine) and illustrations for novels, such as *Tatakau Shisho to Kuroari no Meikyu* ("Fighting Librarian and Labyrinth of Black Ants," Shueisha Super Dash Bunko). He also designs image boards of animation characters and video games.

"Faint Sigh of the Enchanted Princess"

"Faint Sigh of the Enchanted Princess"
— Story of a prince and princess in the fantasy world

Shigeki Maeshima has been featured several times in this series. He presents his latest manga in the following full-colored pages, which reveal his overwhelming vigor in drawing and story making.

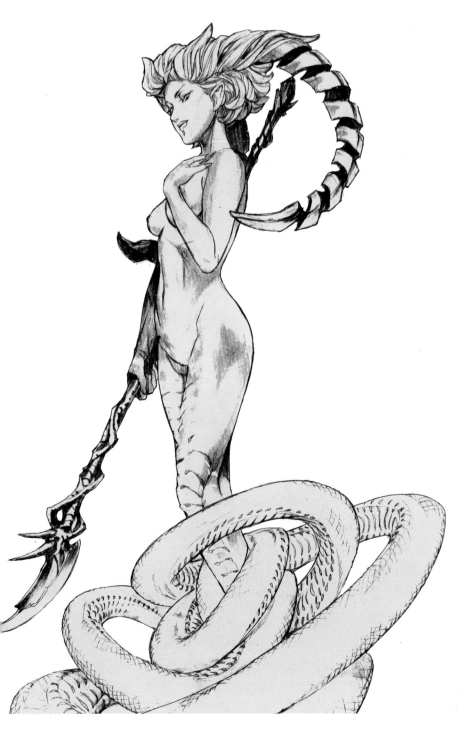

Interview with Shigeki Maeshima

— What is "Faint Sigh of the Enchanted Princess" about?
It's a fantasy story. The main characters are not human beings but monsters, who are considered to be villains. The princess of the enchanted world falls in love with the deceased human prince and gives him a transient life. She ignores the objection of Hades and escapes the world. The princess sets off on a journey to find magical tools and sorcerers to fulfill her promise of reviving the prince.

— What made you write this story?
I wanted to write a story about forbidden love between a princess of the enchanted world and a deceased prince. The closer their dangerous relationship becomes, the more enemies they have to confront.

— What are some of the inside stories?
The princess can use people who have fallen into hell. The prince and the three accomplished villains are examples of such beings. The black horse is also dead. She becomes hostile to the dragon tribe that used to be the relatives of Hades.

— What are the highlights in this story?
The graphical subjects are water and forest woods. There are natural elements in the setting. I hope that the scenes effectively show the moments of transition between stillness and motion.

— How will the story further develop in the upcoming episodes?
I have various ideas about the next episodes. I thought about adding an attendant in the enchanted world who becomes worried and follows the princess; the people search the prince whom they thought had died; or a sequel that tells the rise of the dragon tribe.

Shigeki Maeshima
前島重機

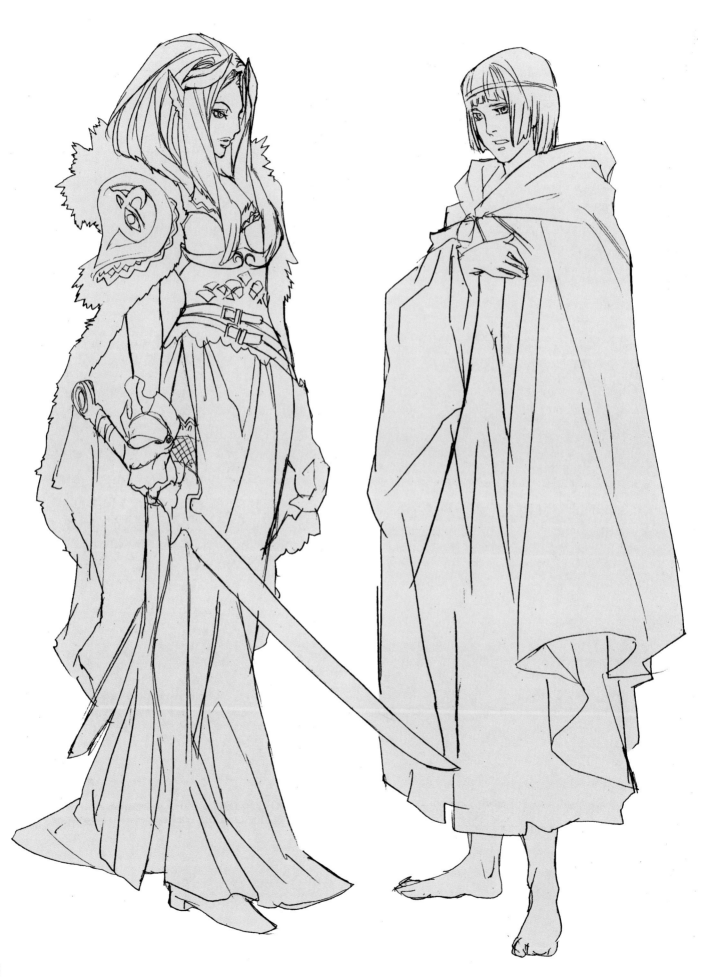

Shigeki: "For the setting, I created an African-inspired princess. I contemplated on how I should dress her: I thought about drawing a dark woman with black armor, but I decided to dress her in white to emphasize her neat and clean image."

Shigeki Maeshima's Publications

"Dragon Fly"

A serial manga featured in the full-colored comic magazine *robot* under the direction of Chief Editor Range Murata. Shigeki participated in the exhibition "Range Murata x robot" during the COMITIA 76 (Original Independence Comic Exhibition in Japan) event in 2006, where he also exhibited his sketches and line drawings for the latest issue of *Comickers* Vol. 5.

Publisher: Wanimagazine
http://www.wani.com/

"Tatakau Shisho to Kuroari no Meikyu" ("Fighting Librarian and Labyrinth of Black Ants")

A dead man turns into a book and is stored in the library. Young Coreo Tonis tries to kill the strongest librarian in the world. Shigeki's overwhelming manga world is a popular serial published in three volumes.

Publisher: Shueisha Super Dash Bunko

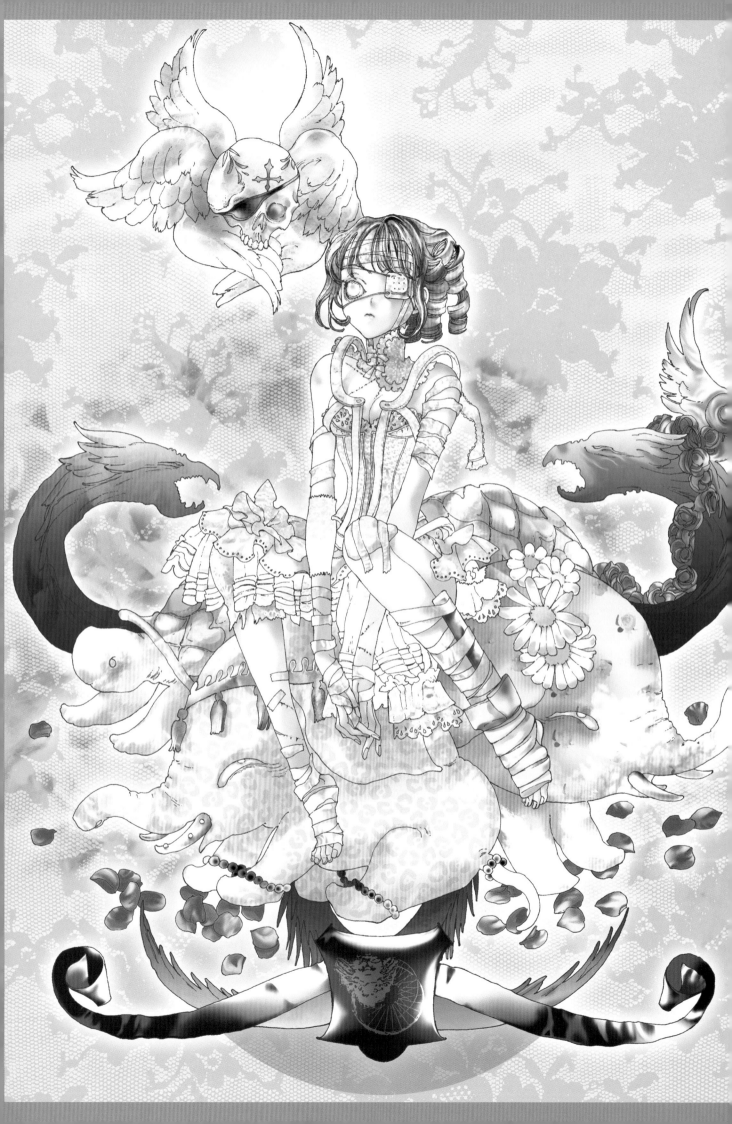

Miou Takaya

高屋未央

Born in Aichi Prefecture, Japan, Miou is a manga artist and illustrator. In 1993, she debuted as a book designer for *Kaihouyouembu—Episode Suzaku* (by Minako Fuji, Tokuma Novels). Her major manga works include "Kikaijikake no Osama (Mechanical King)" (Taiyotosho), "Opioid Substance Endorphin" (Taiyotosho), and others. She is also noted for her illustrations in "Muma no Tabibito" (by Mayumi Shinoda, Hakusensha), "Otosareshi Mono" (by Mayumi Shinoda, Tokuma Dual Bunko) and "Sharian no Maen" (by Yuki Rin, Shueisha Cobalt Bunko). Her picture collections include "Tengokukyo" and "Seishozu" (both from Bijutsu Shuppan-sha).

http://www1.linkclub.or.jp/~miou/

Miou has made a great impact on many readers of *Comickers* magazine with her manga illustrations in gold and black. As a manga and novel illustrator, she draws scenes filled with roses, angles, skeletons, and other motifs showing delicate lines. Many of her works depict themes that enhance life and death.

Through her picture collection published by *Comickers* magazine and ongoing works for literary coterie magazines, we can see her attitude toward creativity. Her ideas for book designs surpass the boundaries of her works, and she makes them stand out as more than just simple books to read.

Miou's screen compositions and world motifs show us different aspects that influence her designs, which are highlighted in this section.

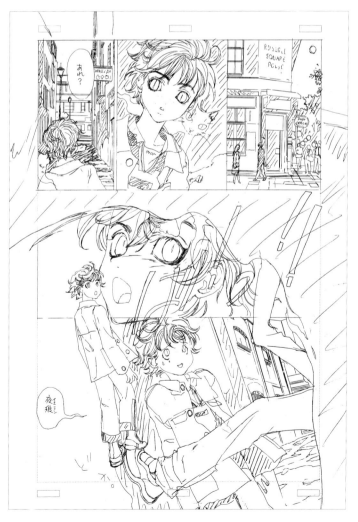

"Opioid Substance Endorphin," serialized in the magazine *CRAFT* (Taiyotosho)
© Taiyotosho/Miou Takaya

Miou Takaya
高屋未央

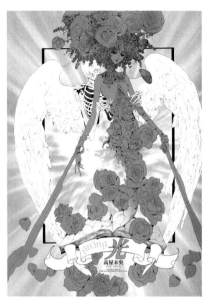

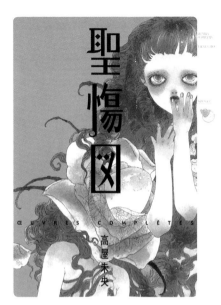

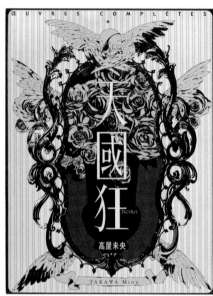

Manga "Light," printed in the winter 2000 edition of *Comickers*, and reprinted in "Tengokukyo"

Beautiful book designs in gold and silver from Miou's picture collections "Tengokukyo (Heaven Can Wait)" and "Seishozu" (both published by Bijutsu Shuppan-sha)

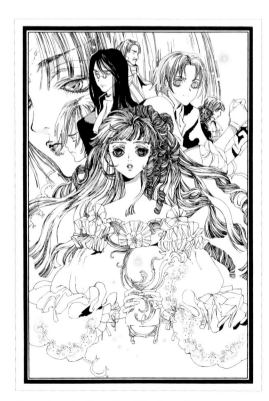

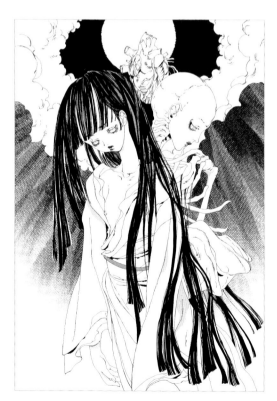

Illustrations for "Auto Mart" (by Sawa Nanase, Koudansha X-bunko)
© Sawa Nanase, Miou Takaya/Koudansha

Illustrations for "Yozan Ningyo" (by Shin'ichi Tatatsu) in the magazine *SF Japan* (Tokuma Shoten)
© Shin'ichi Tatatsu, Miou Takaya/Tokuma Shoten

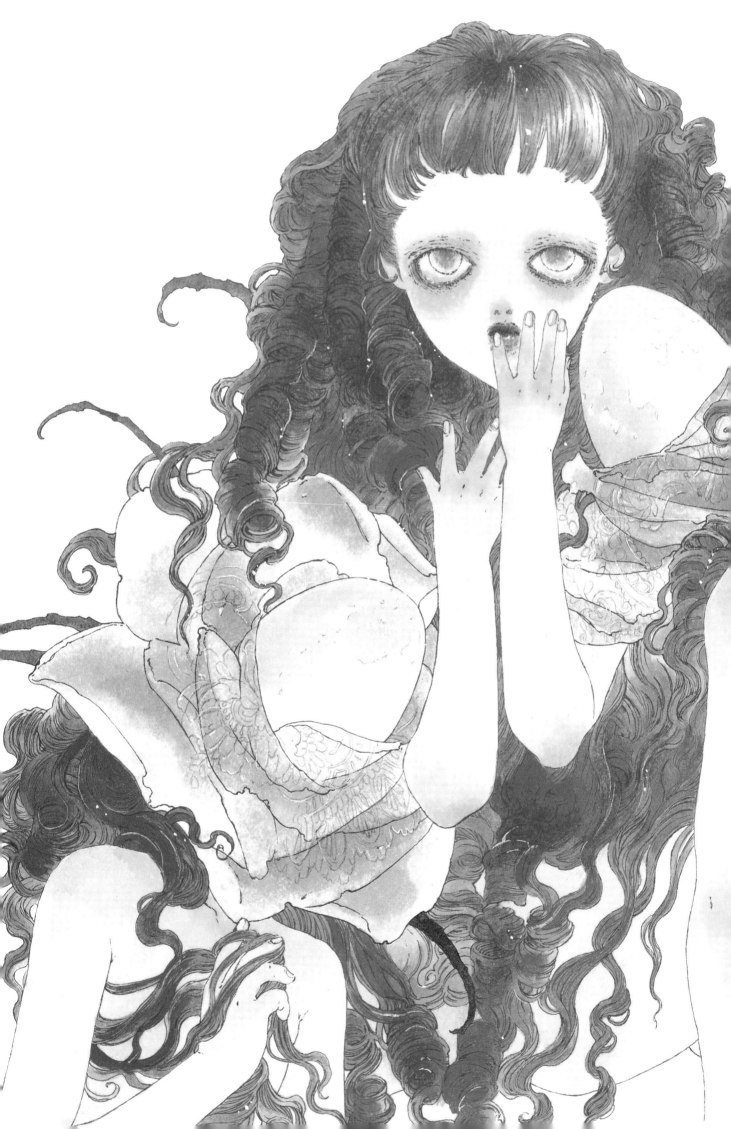

Miou Takaya
高屋未央

Drawing Models of "Cogito Ergo Sum"

This section presents the detailed process (from plotting, drawing with ink to coloring) of Miou's manga creation "Cogito Ergo Sum," featured on pages 113–120.

Miou begins by writing the plot. She always carries a notebook or a piece of paper, and takes down notes when she comes up with words for her story. She organizes the theme and forms the story, while further elaborating the text. Then, she determines the pagination based on the text flow. She usually transfers the storyboard directly into a graphic expression without making any changes.

The story "Cogito Ergo Sum" is an exception. It has changed significantly from its initial idea. She originally thought of a charming story about different views of life and death between Eastern and Western cultures, with references from world myths, such as "Izanagi Izanami" and "Orpheus." The manga "Mado Jigoku-hen" printed in the previous issue of *Comickers Art Style Vol. 1* reflects this theme.

The phrase "Cogito Ergo Sum" is also the protagonist's name and a famous phrase by René Descartes.

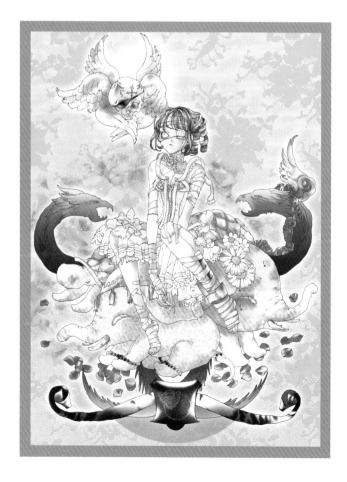

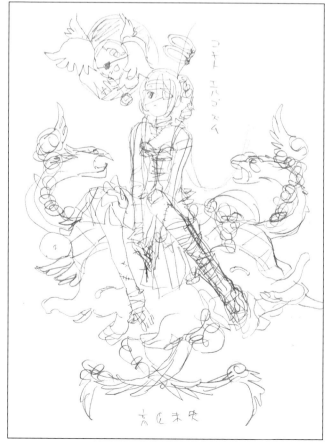

Left sheet of paper: Text flow that resembles a scenario
Right sheet of paper: First notes about the plot. Miou always takes down notes to form the story.

Miou draws a graphic storyboard based on the text flow. She creates the settings and rough drawings quickly on pieces of paper, then throws them away several times. Sometimes she thinks of a setting without writing it down.

From the rough drawing, she uses a clean copy of the graphic storyboard to discuss the story with the editors. Otherwise, she skips this process and proceeds to enlarge and photocopy the storyboard to trace it for the rough drawing.

To work digitally, she draws each part carefully by dividing the picture into smaller parts. Sometimes she uses ink without the rough drawing, and traces instead. The diagrams on pages 72-73 show the same illustration for each step for better comprehension of the creation process.

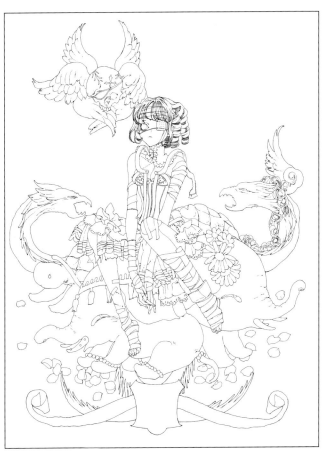

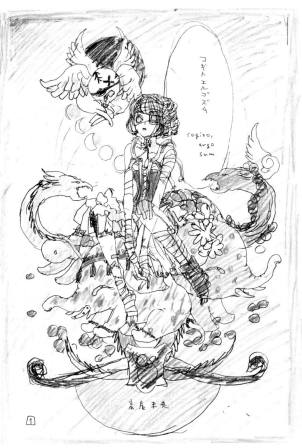

Miou Takaya
高屋未央

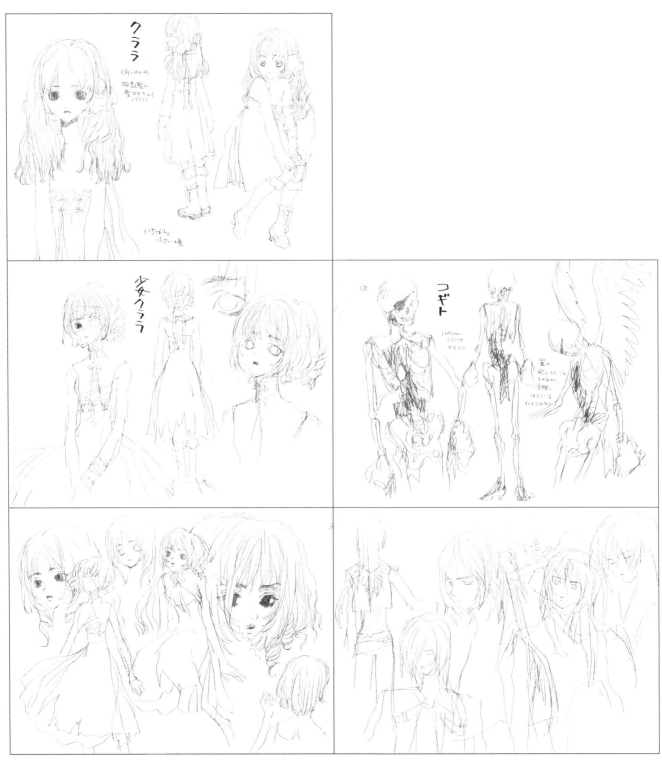

Character setting for Chiara and Cogito

Rough Drawing

 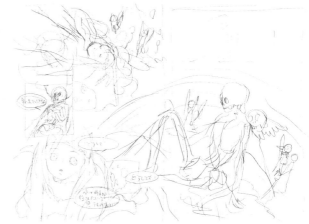

Graphic Storyboard

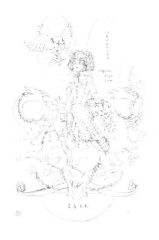 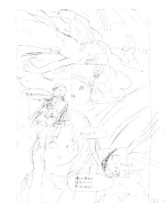 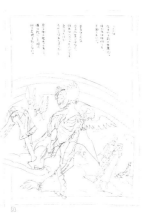

Sketch

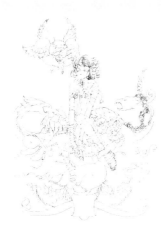 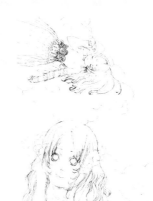

Ink Drawing

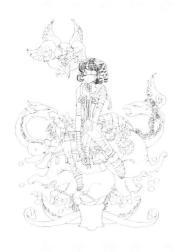

Miou Takaya
高屋未央

Rough
Drawing

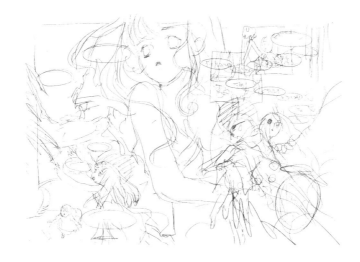

Graphic
Storyboard

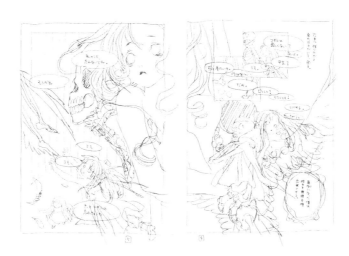

Sketch

Ink Drawing

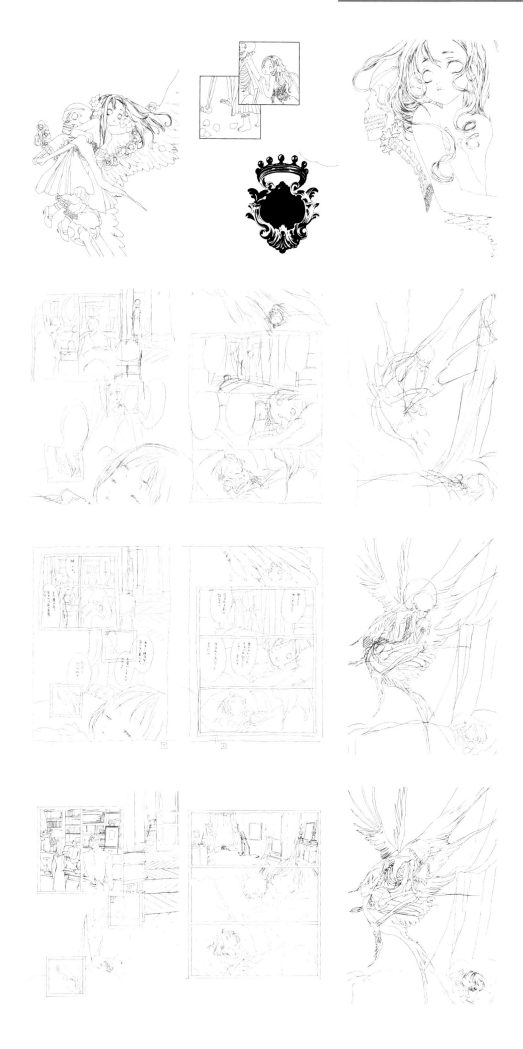

Miou Takaya
高屋未央

Drawing Models by Miou Takaya

The previous pages demonstrate Miou's story-making process, from plotting to applying ink. This section presents the coloring process.

Preparation

Miou finalizes the color planning and captures the ink line drawing with a scanner to create digital data. This is the beginning of the coloring process.

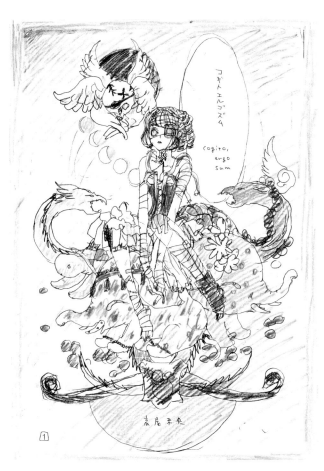

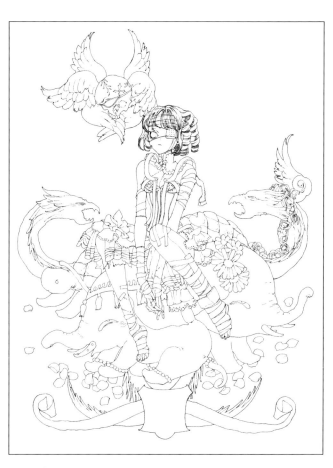

step 1

First, she places roughly planned colors on a copy of the graphic storyboard using colored pencils. She makes several patterns, then she picks up one of them to use as a color plan. She has decided to use pink for the background of this title page, so she makes only one pattern of the color plan.

step 2

She scans the inked line drawing at grayscale 600 dpi resolution. She moves from "image > levels" to reduce the paper shades slightly, then she repeats the following steps several times: levels > shade > maximum brightness > shade > unsharp mask > shade > sharp, to adjust the lines. She enlarges the picture by 200 to 400 percent to see the outcome. Then she removes the dust.

She adjusts the levels of shades into the size of the script, and changes the process color to 350 dpi resolution, adjusting it with more sharpness.

step 3

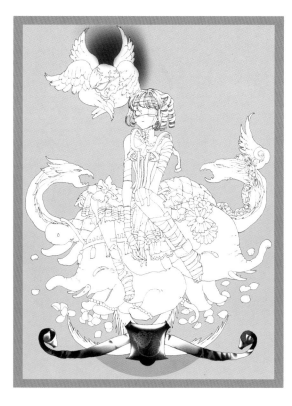

She puts weight on the entire image of the illustration because it constitutes the title page. Then she roughly paints the ground color that occupies a wide area. She finalizes the colors at this stage. The image of the pink background and the frame color is a box of Demel chocolate. She selects the main lines with channels and paints with blackish purple (C100M100Y60K10), placing the image on the top layer.

Full Coloring

Miou roughly colors each motif. Her method is to paint flatly while layering shades over each other. She also adds texture at this stage

step 4

She picks a color from the background to paint the elephant under the girl. For the background, she scanned her own raschel lace and uses it as a texture. since she wants to express a girlish atmosphere. She makes two types of rose motifs, then copies and pastes them as patterns on the elephant at the right side. She makes them look like designs done by the process "Pixelate > Facet." The colors of the roses will be reduced later; for now, it is sufficient that they match the overall tone.

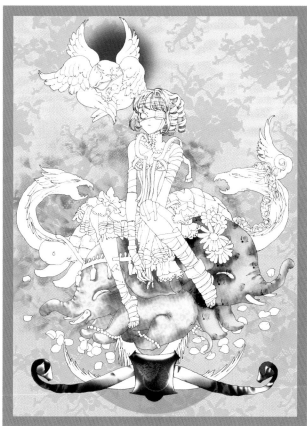

Miou Takaya
高屋未央

From Detailed Coloring to Color Correction

Miou proceeds to paint the details. She draws the shades over them. While adding texture, she corrects colors and overviews the whole picture.

step 5

She colors the picture in the order of dragon, rose, turtle, and Chiara's skin. The color groups are roughly divided into four parts: background lace; Chiara and Cogito (skeleton angel in the sky); obi belt in the lower area; and elephants, dragon, turtle and petals. The self-made materials are overlaid as such: bobbin lace (thread lace) over Chiara and Cogito, raschel lace in the background, and rose bouquets over the elephants and the background.

She makes significant changes in the entire color scheme at the end. This works as long as the color density is defined and the objects can be distinguished at the coloring stage. She continues coloring without being bothered by her tastes of subtle color matching.

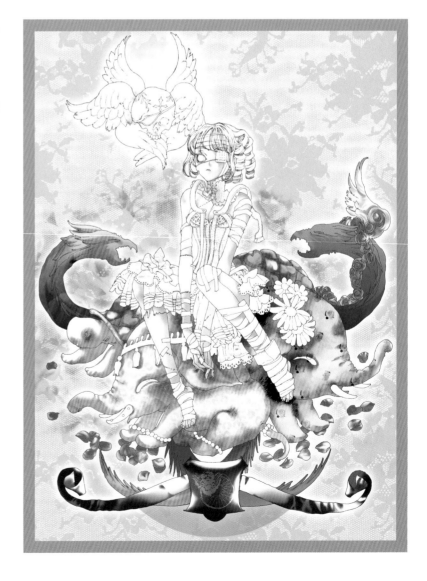

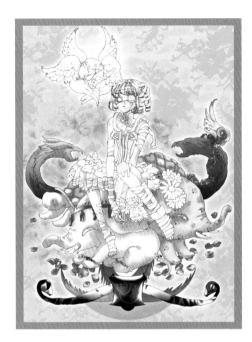

step 6

The rose bouquets are overlaid on the pink background and the animals at this stage, but Miou also plans to divide the image into the parts of the elephants, turtle, dragon, and background, and to adjust their colors. This version shows the color tone as it has been changed. The drawing looks better when the entire colors are reduced, but she leaves the rose petals red.

step 7

In the final stage, she has reduced the tone and changed the two dragons behind into a silhouette-like appearance. She could have added more touches on Chiara's corset and skirt, but she stopped halfway to leave the bobbin laces that have been overlaid. The pictures below are some of the layers altered into special modes and patterns.

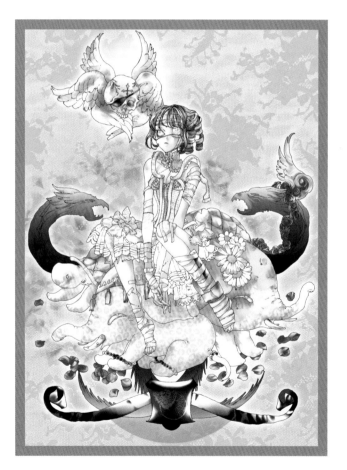

Laces around Chiara and Cogito using Overlay and Hue

Rose background using Color Burn

Character against the rose background using Lighten

Miou Takaya
高屋未央

Preparation

Miou combines the ink materials of separate parts into one sheet in order to create a digital data. Then, she paints the background to shape it into designed material.

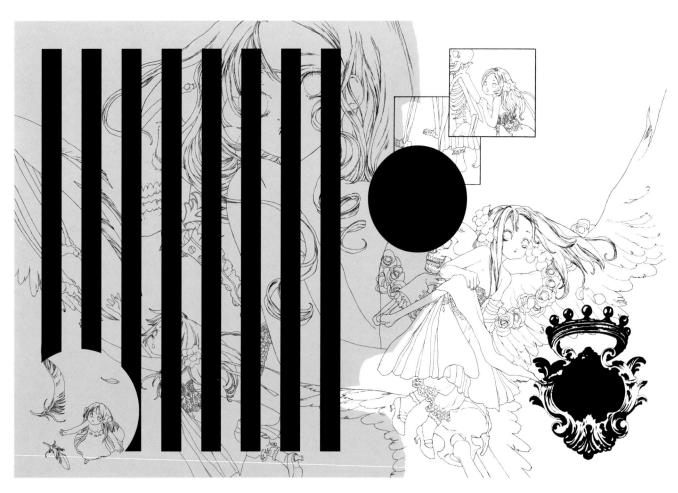

step 8

The central part is laid across the fourth and fifth pages, so the entire picture is created as one page in facing pages. After applying ink on each divided part of this page, she creates digital data of the combined picture. She scans five line drawings at 600 dpi grayscale. After correcting the lines as she also did for the title page, she adjusts the size to fit the 600 dpi screen of facing pages by enlarging or shrinking, removing dust, altering to 350 dpi CMYK, and processing by "Filter > sharp."

She makes other designs, such as the circle behind Cogito and the vertical stripes in the left background. The circle and lines function as guides for directing readers from the right side to the lower side, and from the lower right to the left page. The wings of Cogito also have a meaning in this visual guide. The screen looks quite complex; thus, it is organized more effectively with a viewing route in an S shape.

Miou applies the color of the background on the left page, which is the same M30Y20 pink color used on the title page. She paints it as part of the materials. At this stage, the picture is clearly defined.

From Final Coloring to Completion

Miou proceeds overlaying colors from one part to another. As she has done for the title page, she also adds shades and pastes texture.

step 9

These pictures show the layers of each separate part.

Rose pattern background using three types of overlaid colors: Normal + Hue + Color Burn

Pattern used in the pink background on the right page

Lace texture laid over the wings. Miou uses the black background to see it clearly since it is overlaid with a "lightened layer."

Principal lines of two characters in the center. Dark blue purple and red purple are overlaid.

step 10

Miou captures the principal lines for each part, selects ranges, and saves the channels. Then, she paints the background and characters, and overlays her own rose background. While studying the entire picture, she adds a step effect and frames to finish.

The color of the principal lines differs for each part. The part that includes a "little girl," for instance, is a gradation of darker red brown (C50M80Y100) to yellow ocher (C40M50Y100), and the part with two characters is a filtered mix of dark blue purple (C100M100Y60K10) and red purple (M50K50). However, the original colors are difficult to identify because the copied layers with blurred lines are overlaid to bring out the proper color effect.

She begins to color the central part that includes the two characters, which take up a large portion of the entire illustration.

The result looks like manga scripts when speech balloons are added.

Principal lines of a small Chiara in the lower left side, which is gradated from red brown to yellow ocher.

Rose designs laid over the upper-right frames, which stand out clearly with the black background since it is overlaid with "screens."

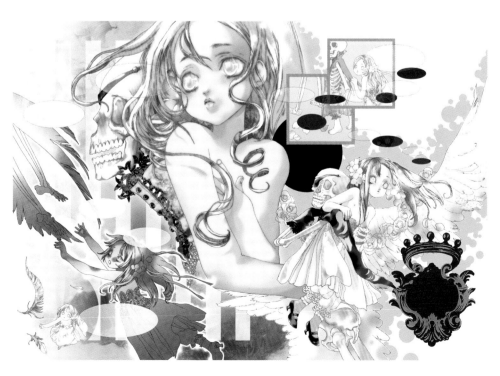

2

Gallery:

Hot New Talent

"Girl Neighbors"

Kana Otsuki, age 21, Kyoto
Acrylic paint/colored pencils

"Elementary school kids can be stubborn but charming. Lately, I rarely see kids play outside, so I drew this illustration in the hope of seeing them run around during a festival. I believe this is how children should be."

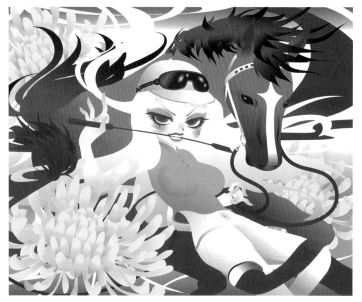

"Heroine—Many Bodies, One in Mind"

Hargon's Wig, age 28, Kagawa Prefecture
Illustrator 8.0J

"I always wanted to draw a horse, and I enjoyed drawing it."

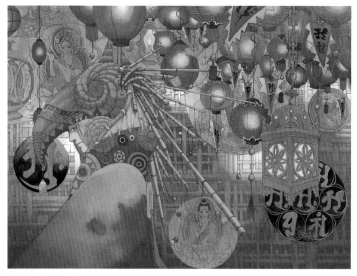

"Pilgrimage"

Toyo, age 22, Kanagawa Prefecture
Watercolor paper/acrylic paint/colored ink

"I learned a lot in painting this picture, and I need to review it more."

"Untitled"

Rie Toi, age 21, Shiga Prefecture
Transparent watercolor/colored pencils

"I like the lights around the bar stand, and the good smell of the food."

"Moment of Rest"

Shinobu, Osaka
Acrylic modeling paste

"I hoped to draw an illustration that spins out a story."

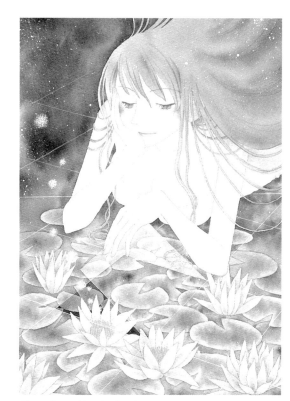

"Star Dust Music Box"

noa, Tokyo
Transparent watercolor/pen/pastel

"The blink of the stars seems like music."

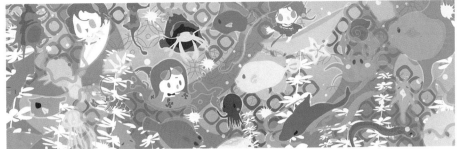

"Going to the Beach"
mumu, Tottori Prefecture
Illustrator

"This illustration has a fun and summerlike atmosphere. The motifs are cheerful, although the colors of the background design seem too strong compared to the colors of the fish and the human characters."

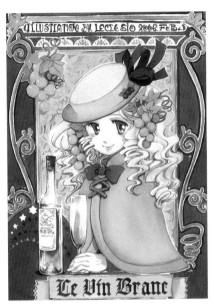

"Le Vin Blanc"

Leclè Sio, Tokyo
Colored ink

"This picture is an image of wealth."

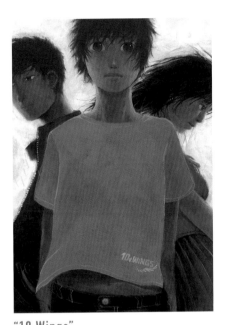

"10 Wings"

Noboru Asahi, age 19, Kyoto
Acrylic gouache

"I had abandoned this picture for a long time, but I am relieved that I was able to present it for others to see. I drew it to expand my imagination of manga."

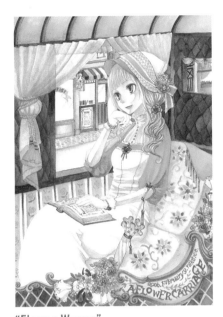

"Flower Wagon"

Rakishisu, Fukuoka Prefecture
Transparent watercolor

"I tried to bring out a nostalgic atmosphere."

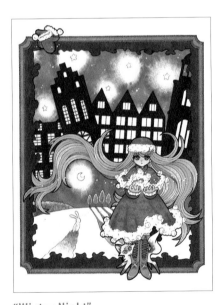

"Winter Night"

ATUSI, age 36, Kanagawa Prefecture
Transparent watercolor/Copic/water ball point/
Indian ink

"I drew this picture with an image of a European fairy tale. I had a hard time coloring the sky; I barely managed to complete it in six sheets."

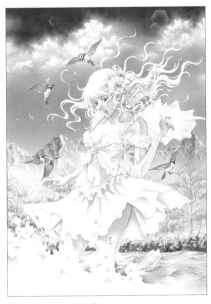

"Instant Beauty"

Yui Kaoru, Hokkaido
Transparent and opaque watercolor/colored ink/Copic

"After spending many days outside my home, I got an urge to draw a picture of the pleasant natural environment."

"Into a Dream"

Jun Sakaki, age 19, Nagano Prefecture
Transparent watercolor

"I came up with this idea when I was drowsy."

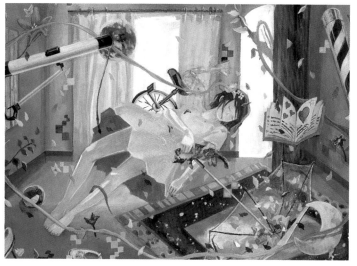

"Water Room"

Yukihiro Nakamura, age 22, Nara Prefecture
Acrylic paint

"I wanted to draw a picture that can heal the viewers' minds and help them to live well."

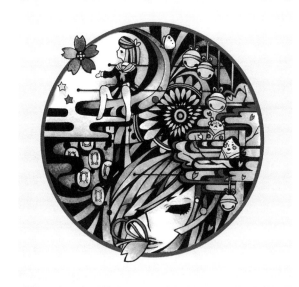

"Sakura Drops"

Yuka Okabe, age 22, Hyogo Prefecture
Japanese pigment/colored ink

"People build the flow of time as they come together or separate from each other. I drew this picture with an image of girls who grow up together."

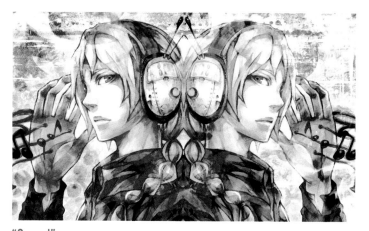

"Sound"

Yomosugara, age 18, Hokkaido
Colored pencil/Copic/Photoshop

"I rearranged the elements in this picture that I had drawn a long time ago."

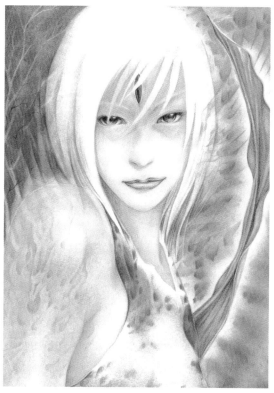

"Dressed in the Night Air"

Kumocchi, age 24, Ehime Prefecture
Watercolor pencil

"I rarely use a blue pencil, so I wanted to use red."

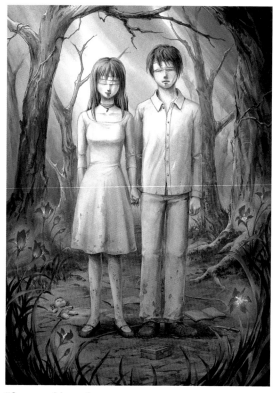

"Grove of Love"

Sugata Mimi, age 25, Tokyo
Poster color

"It's hard to know what's important in this world, and I thought of this while drawing this picture."

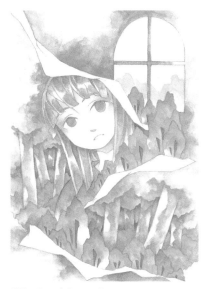

"Shade of Grove"

Hamikko, age 24, Fukui Prefecture
Gansai paint

"I think this picture represents some hesitation."

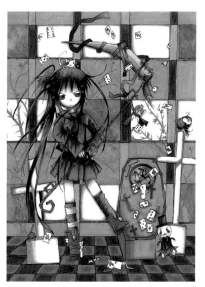

"Fragile Dream"

NOELU, age 14, Hiroshima Prefecture
Copic/Neopiko

"I drew this picture with an image of the joker in a deck of cards playing. I enjoyed painting the areas in red, and I wanted the viewers to notice the blood-covered cat at the bottom of the picture."

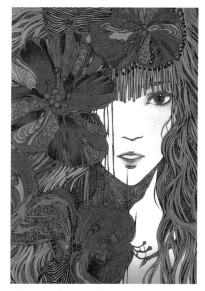

"Flower Garden"

Sakae Kashiwao, age 22, Kanagawa Prefecture
Copic/pastel/drawing pencil/colored pencils/fine drawing pen

"I had a hard time determining the position of the flowers."

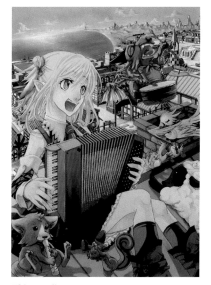

"Singer"

Erii Mano, Aichi
Painter 6

"I would be happy if my drawing expresses cheerfulness."

"Sweet Sisters"

Itachi, age 21, Osaka
Photoshop

"Doing the laced parts was difficult. I created the letters myself. As I was drawing this picture, I struggled with the technique of achieving transparency in the candies."

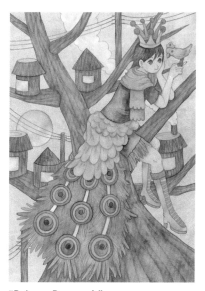

"Prince Peacock"

Mushimaru, age 21, Miyagi Prefecture
Watercolor

"I wanted to draw mainly the wooden house and the telephone poles. It was hard to see the moon because the background was not dark enough, but the scene actually takes place during the night."

"Thoughts of the Princess Mermaid"

Natsuna Niikura, age 20, Saitama Prefecture
Liquitex

"I used Liquitex for the first time. I am happy to have finished this work about a princess mermaid, which I had wanted to draw for a long time."

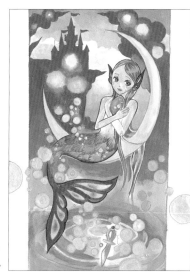

"Have a Nice Dinner"

Eri, age 19, Aichi Prefecture
Copic/poster color

"I drew this picture after I watched a show on Chanel, then I ate roast pork."

"Wind of First Love"

Koichi Inada, age 21, Tokyo
Copic/G pen

"I would be happy if viewers can feel something from this work."

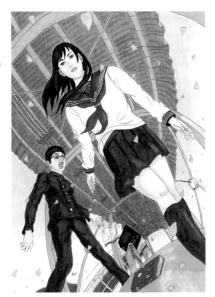

"Paradise"

Tomomi, Kyoto
Photoshop

"I don't think the little girl in the picture looks like me."

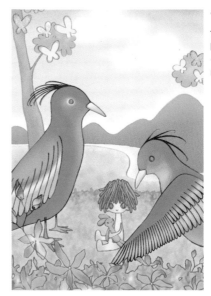

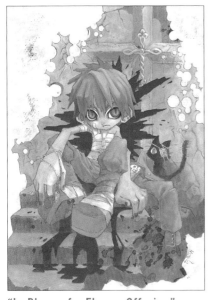

"In Place of a Flower Offering"

Mizuki, age 21, Shizuoka Prefecture
Acrylic gouache/gesso/colored pencils

"I drew this picture in the shortest time ever, then I realized that I could do it."

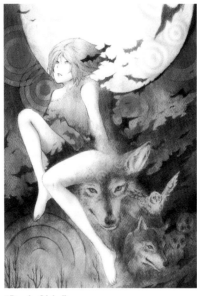

"Dark Side"

aono, age 21, Tokyo
Pencil/colored ink/Photoshop

"I tried to express a fantastic world with a subject on the "hidden side of the mind.""

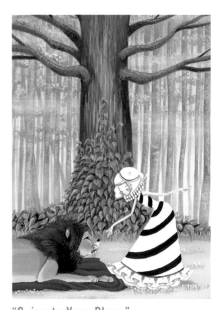

"Going to Your Place"

Maro, Hokkaido
Liquitex/acrylic gouache/watercolor pencil

"It's always difficult to make a comment about my drawing."

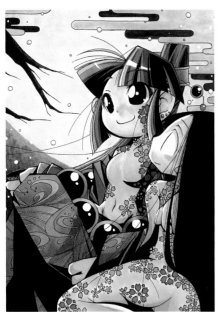

"Beautiful Things"

Atsuto Tsukishiro, age 24, Kyoto
Pen/colored ink

"Things that depict real beauty or importance are the most fragile elements in life. We want to protect them even if they might hurt us."

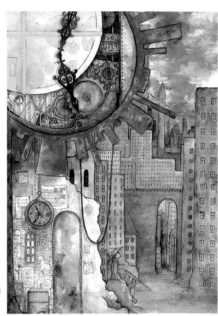

"City of Cogs"

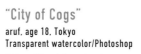

aruf, age 18, Tokyo
Transparent watercolor/Photoshop

"I drew this picture about a year ago, and since then I think I have improved myself. I feel that this picture reflects my starting point."

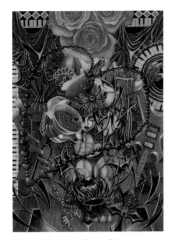

"Love is Nowhere"

Hitomi Igarashi Johanson, age 16, Saitama Prefecture
Acrylic gouache

"I collected various things related to a sensual relationship."

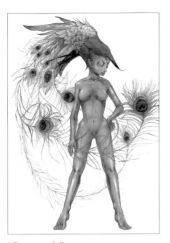

"Peacock"

Sugiko Nakajo, age 24, Tokyo
Acrylic/colored pencils

"I tried to express a gorgeous peacock."

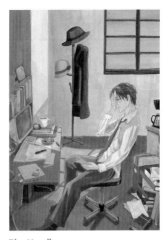

"Letter"

Tayu Tachibana, age 23, Tokyo
Acrylic paint/colored pencils

"I wanted to draw a middle-aged man, but I paid too much attention to the surroundings. I will draw a more attractive man next time."

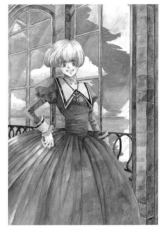

"My Favorite Place"

Yumi Nishi, age 22, Kyoto
Transparent watercolor/colored pencils

"I drew this picture with an old-fashioned taste."

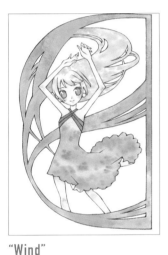

"Wind"

Koun Ryusui, age 20, Tokyo
Transparent watercolor

"I drew this painting with an image of the blowing wind."

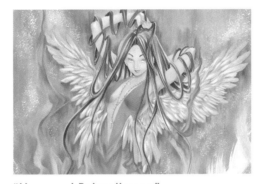

"Above and Below Heaven"

Kazuki Kuse, age 23, Yamaguchi Prefecture
Acrylic gouache/Copic/colored pencils/gesso

"I forgot to draw on A4 paper first, so I had to cut the frame into the designated size. Unfortunately, this made the picture look slightly cramped."

"A Witch and a Boy"

Masato Murata, age 24, Kanagawa Prefecture
Copic

"I enjoyed painting the characters."

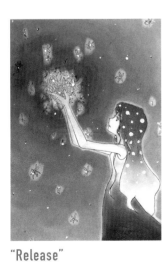

"Release"

Kokusho, age 19, Niigata Prefecture
Kent paper/pastel

"I painted this picture with a frail and mysterious finish, which I hope the viewers can also feel."

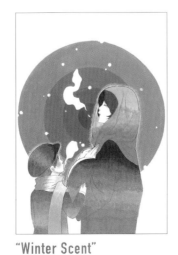

"Winter Scent"

Mayumi Watanabe, age 19, Niigata Prefecture
Copic/acrylic gouache

"I drew this picture with an image of the winter night departing."

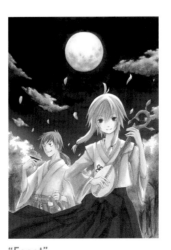

"Feast"

Maki Uehara, age 19, Niigata Prefecture
Copic/air brush/Copic multiliner

"It was hard to paint the night sky beautifully."

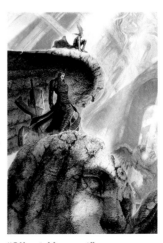

"Silent Moment"

Masako, Yamaguchi Prefecture
Acrylic gouache/Liquitex

"A weary light passes through this abandoned place where time travels very quietly. The two characters visit this place occasionally."

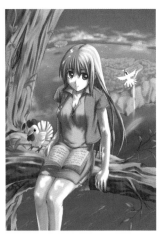

"Hanging Garden"

Ryo Unasaka, age 18, Niigata Prefecture
Photoshop

"The color saturation level in this drawing is pretty high."

"The Stage"

Nijiko, Osaka
Copic/cartridge writing brush

"I sing about love and play about dreams in my guitar."

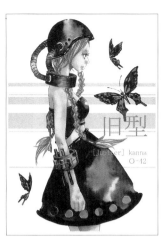

"Old Model"

kanna, age 25, Tokyo
Colored ink/acrylic/Photoshop

"I used black a lot because I wanted to express a heavy feeling."

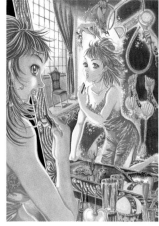

"Labyrinth and a Woman"

Onono, Osaka
Acrylic gouache/Copic multiliner

"I drew this picture by giving more attention to the coherence of the colors, because I always use so many colors that my pictures lose their sense of unity."

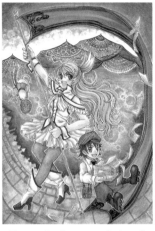

"Circus in Dreamy Colors"

Kumiko Onda, age 19, Tokyo
Copic/colored pencils/white pen

"I drew this picture in hope that it would depict a fun atmosphere. Some areas seem unskillfully done, but I enjoyed coloring this picture."

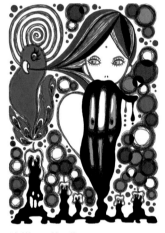

"I Want You"

Manami Kondo, age 19, Niigata Prefecture
Acrylic gouache/pen

"I wanted to make the picture look gaudy, so I drew sloppy lines purposely."

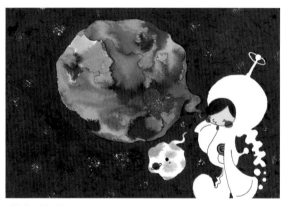

"Help Me!"

Erika Koyama, age 19, Niigata Prefecture
Acrylic gouache/pen

"I drew this picture with myself as the subject, not being able to come up with any other idea. I like the parts done with colored inks."

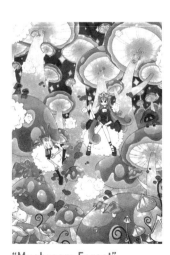

"Mushroom Forest"

Hayu Matsushita, Aichi Prefecture
Colored pencils/Photoshop

"I wanted to draw a world of mushrooms."

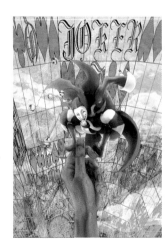

"Old Maid"

Yu Sekisho, age 20, Wakayama Prefecture
Photoshop/Painter

"As I drew this picture, I tried to avoid creating a dark atmosphere. The lead character is an old maid."

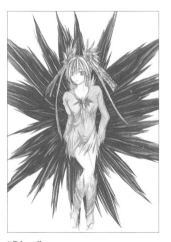

"Blue"

T.K., age 18, Nagasaki
Acrylic gouache

"Winter gives me a blue impression."

"Strolling Across the Starry Sky"

Yuzuki, age 21, Tochigi Prefecture
Transparent watercolor/colored pencils/Copic

"There is a boy and a girl strolling around this starry sky. I wanted to draw a picture of fantasy."

"Detective Story"

Sumiyo Maeda, Kyoto
Watercolor

"I created a special layout to emphasize focus."

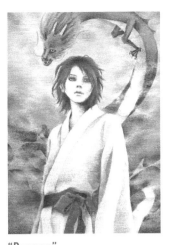

"Dragon"

Kira Sunahara, Hokkaido
Watercolor pencils/turpentine

"This is an image of a dragon king."

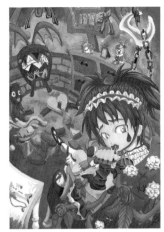

"Dissatisfaction"

Haruna Sakyo, age 25, Kyoto
Acrylic gouache

"I enjoyed drawing this picture with my own pace, but I need to draw with more attention to details."

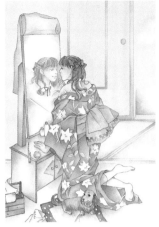

"Secret"

Mai Ugetsu, age 24, Mie Prefecture
Transparent watercolor/thin ink/Kent paper

"The girl in the picture has this thought in her mind, 'My oldest sister was given this kimono last month. I tried it on when everyone else was out. I wonder what you would think if you see me wearing it.' I wanted to draw a desire for transformation. The girl is in a hurry and is not wearing tabi socks, but only regular socks."

"Panda and Cherry Blossom Trees"

Takahiro Horikoshi, age 27, Osaka
Photoshop

"I like all flowers but cherry blossoms are particularly special."

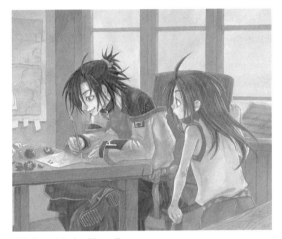

"Wait a Little More"

Kei Minamine, Shiga
Acrylic gouache/Whatman paper

"The warm colors made the picture milder than I intended it to be."

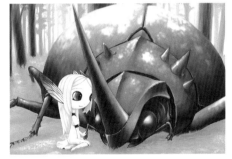

"Silver Metallic Insect"

Kentaro, Tochigi Prefecture
Painter/Photoshop

"I had a hard time printing this picture because I couldn't achieve the colors I wanted."

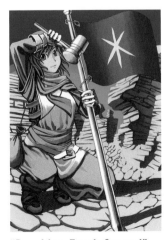

"Breaking Fresh Ground"

Akinori Seyazaki, age 18, Niigata Prefecture
Photoshop

"Adventurers are 'cool.'"

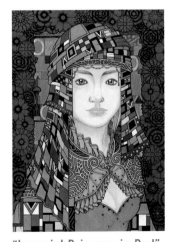

"Imperial Princess in Red"

Koji Fukuchi, Osaka
Copic/colored ink/acrylic paint

"I did not think of anything special, but I drew this picture to test my new drawing method."

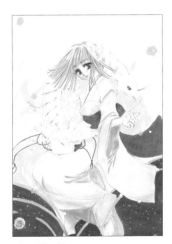

"Untitled"

Aoi Torikai, Niigata Prefecture
Copic/acrylic gouache

"I wanted to make the overall atmosphere 'fluffy' but I wasn't able to do so."

"Flying Fish in the Clouds"

silan, age 17, Kyoto
Poster color

"I enjoyed drawing my favorite fish and its patterns."

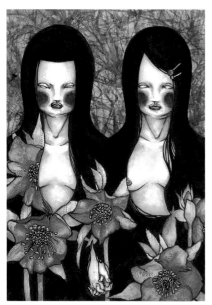

"Erase My Anxiety"

syoco, age 21, Kyoto
Transparent watercolor/acrylic/ Indian ink

"I believe that people always express their feelings with flowers."

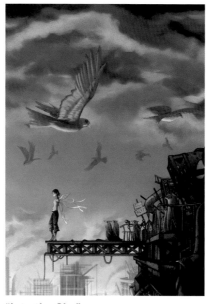

"Into the Sky"

Oropi, age 25, Tokyo
Photoshop

"Sometimes we cannot obtain what we need, yet receive what we don't need. I was absorbed in this thought and came up with this image."

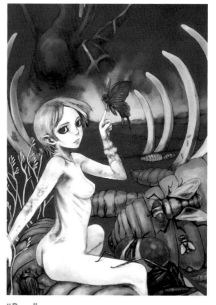

"Bug"

Harigane, age 24, Ibaraki Prefecture
Painter

"I could not finish the work more attractively."

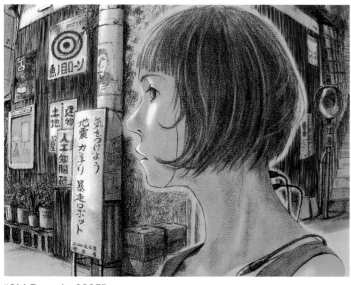

"Old Town in 2085"

SR, age 26, Tokyo
Pencil/Photoshop

"I like the brittle feeling of pencils."

"Fleurs"

Kanan, age 21, Kanagawa Prefecture
Acrylic gouache/ colored pencils

"I drew this picture with an image of a warm spring air among the clouds."

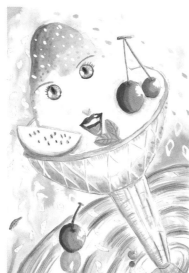

"Flavored Crushed Ice"

Yui Mikazuki, age 21, Saitama Prefecture
Watercolor pencil/colored ink/Copic

"I like crushed ice and turned it into a character."

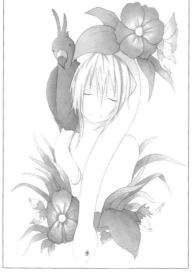

"Dreaming of You Again"

Hoshizukuyo, age 20, Shiga Prefecture
Transparent watercolor

"I have drawn this picture many times and will continually do so in the future."

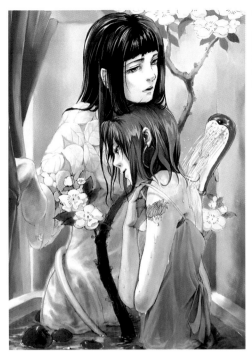

"Apple"
Himemi Sakamoto, age 19, Saitama Prefecture
Photoshop/Painter

"I used a pun (in Japanese language) for the scene and its reference to the apple."

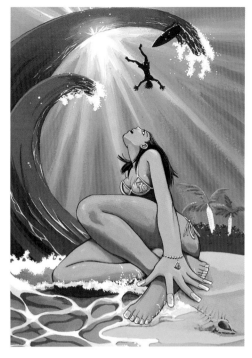

"Yes! The Sea!"
Madoka En, Tokyo
Acrylic gouache

"I attempted using the title of an album of Southern All Stars, my favorite Japanese band. Acrylic gouache was easy to handle because I could redo my drawing with it several times."

"Ombra Mai Fu"
Kinuko Higasa, Hiroshima
Gansai color

"Gansai colors are so beautiful and impressive."

"Laborer's Wife and Flowers in a Desolate Lot"
Anri, age 22, Kanagawa Prefecture
Photoshop/Painter

"I still have a lot to learn about composition and painting the background, and would like to improve my technique gradually."

"Bottle Cap Farmer"
Uju, age 21, Tokyo
Photoshop

"I wish that there was a bottle cap like the one I have drawn in this picture. The farmer complains about the bad behavior of his horses lately."

"Lovely Hair"
Tomo Yachida, age 19, Niigata Prefecture
Liquitex

"This drawing tells about a girl who is always bullied. One day, she was depressed and another girl told her that her hair was nice and matched well with the flower."

"Last Objects"
31db, age 19, Tokyo
Pen/gansai color/watercolor pencil/acrylic gouache

"This drawing shows anxiety toward painting and the future. The scene emphasizes enjoyment of the present moment."

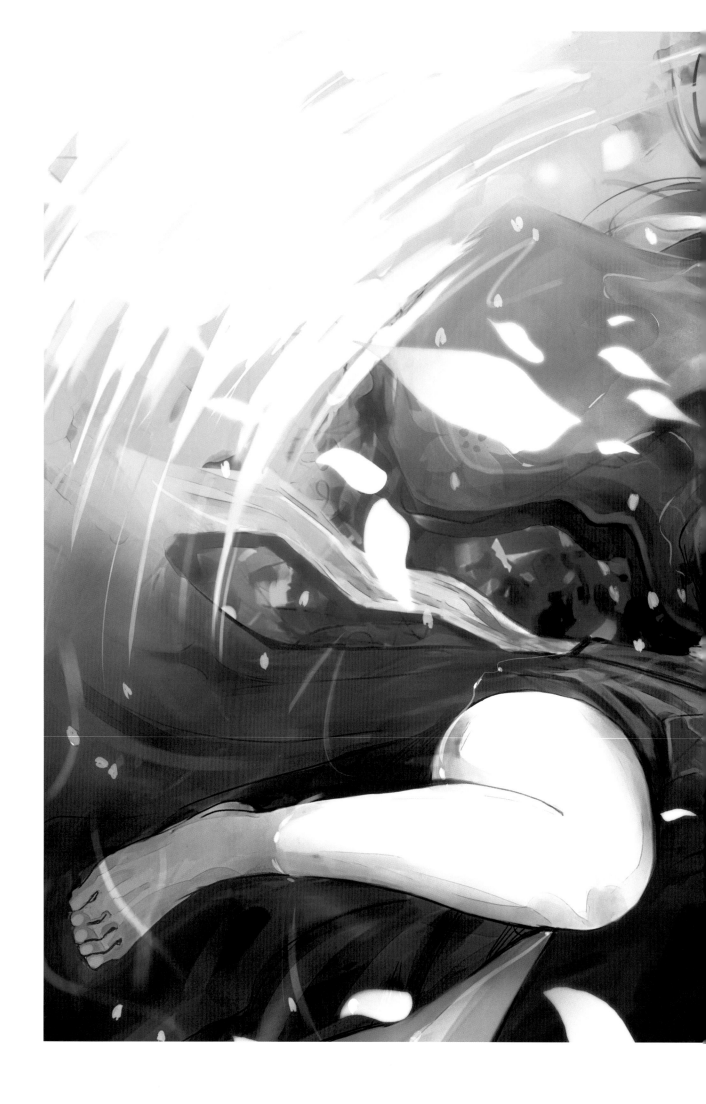

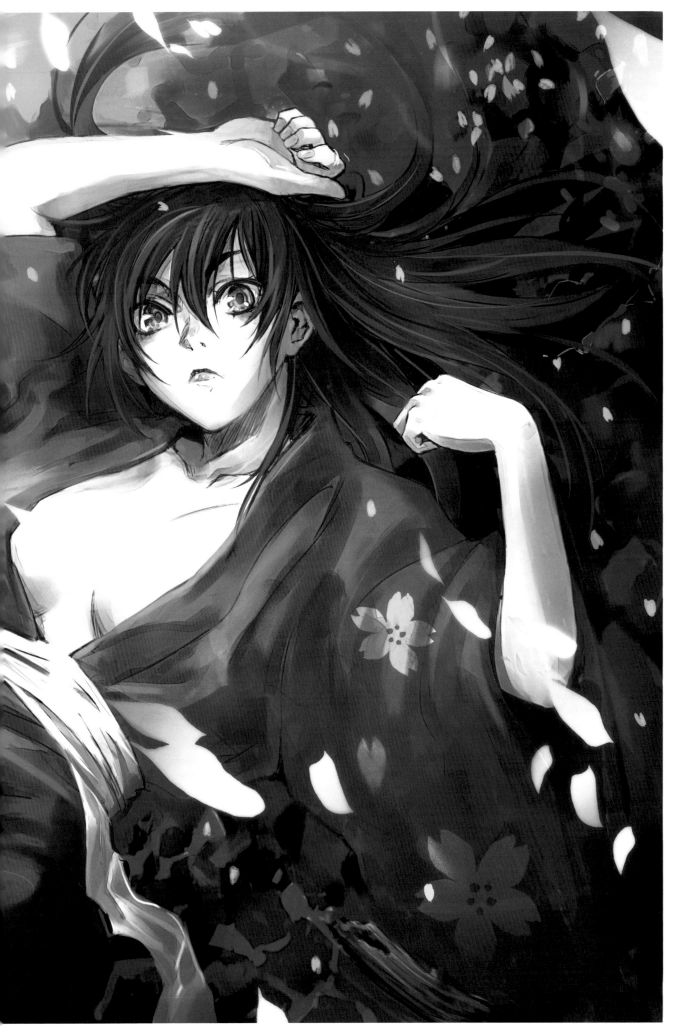

Hideki Yamada (Konchiki)
Born in April. Comic book artist and illustrator. Also known as Konchiki. His art was first published in the manga "Yunagi no Machi" ("Town in a Calm Evening," Fujimi Shobo), and he has published many works for various media, such as novels, video games and magazines.

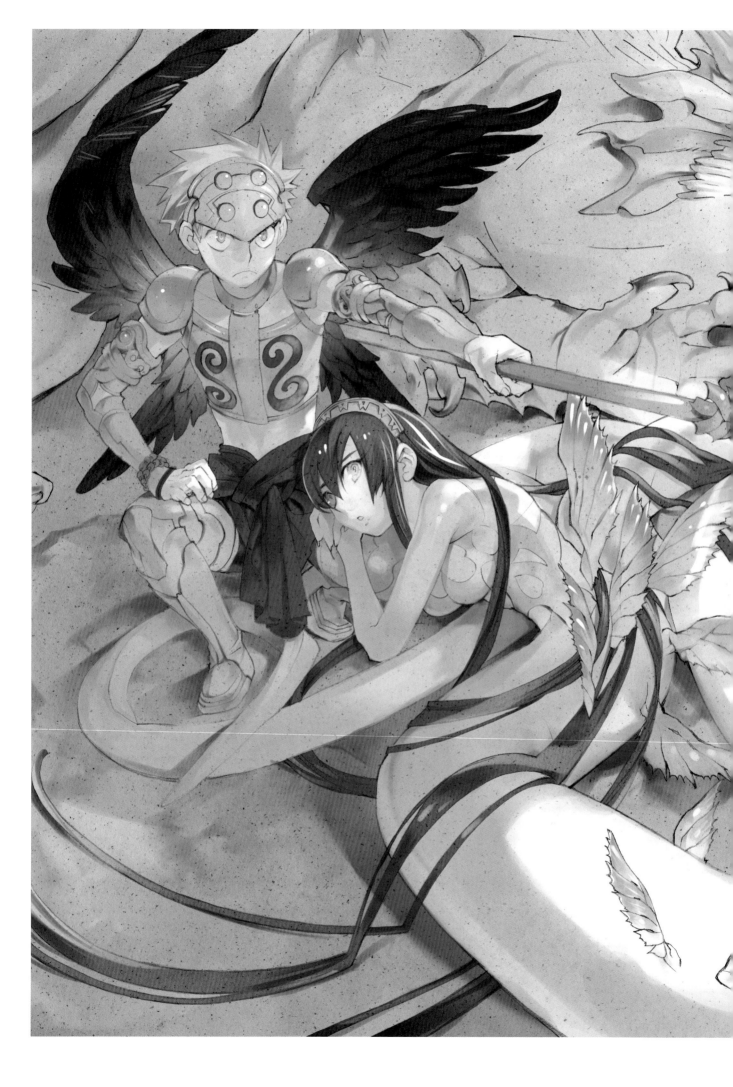

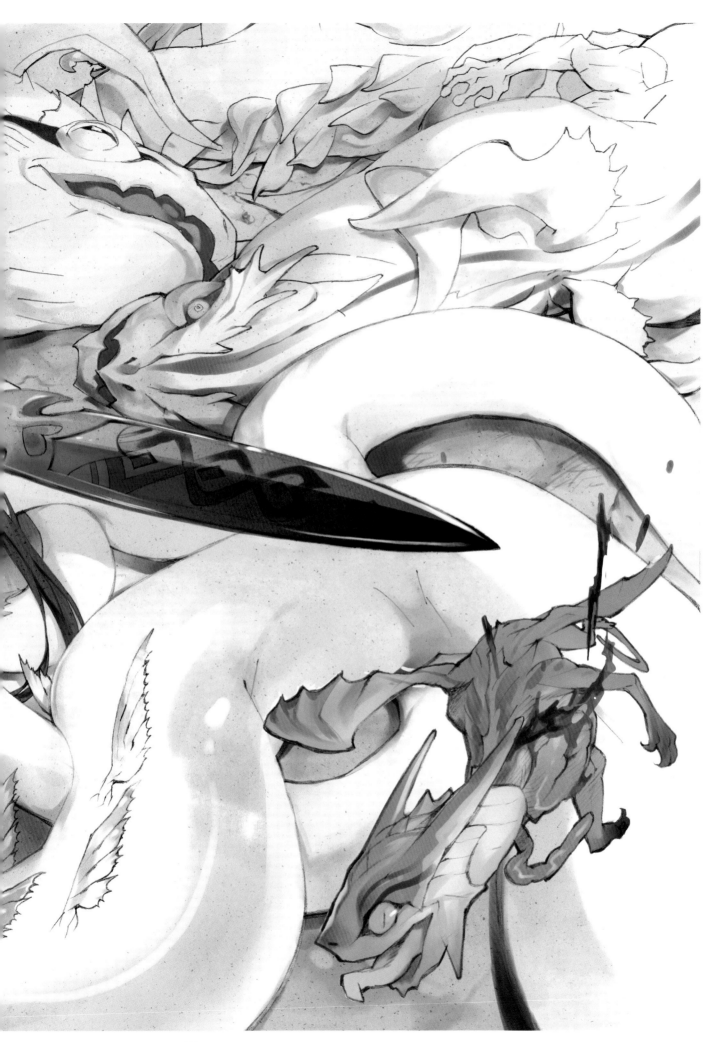

Akira
Comic book artist and illustrator. He drew illustrations for "Yakusoku no Hashira, Rakujitsu no Jou-ou"
("Pillar of Promise, Queen of Sunset," Fujimi Shobo), "Re: Nagino Aoi—Chou Kousoku Kidou Ryushirosen
Haruichiban" ("Aoi Nagino—Super Mobile Fire Ship Haruichiban," Enterbrain), and has also published a manga.

3
Story Manga

This chapter presents three manga stories with accompanying illustrations exclusively created for *Comickers Art*.

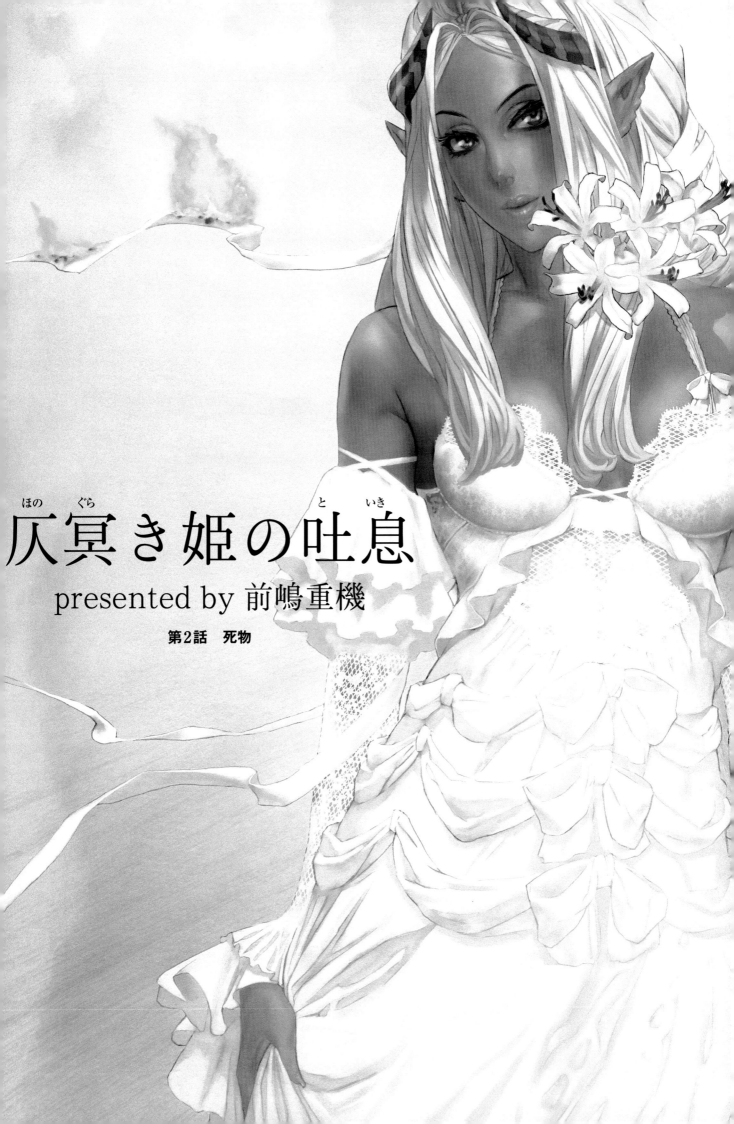

仄冥き姫の吐息

presented by 前嶋重機

第2話　死物

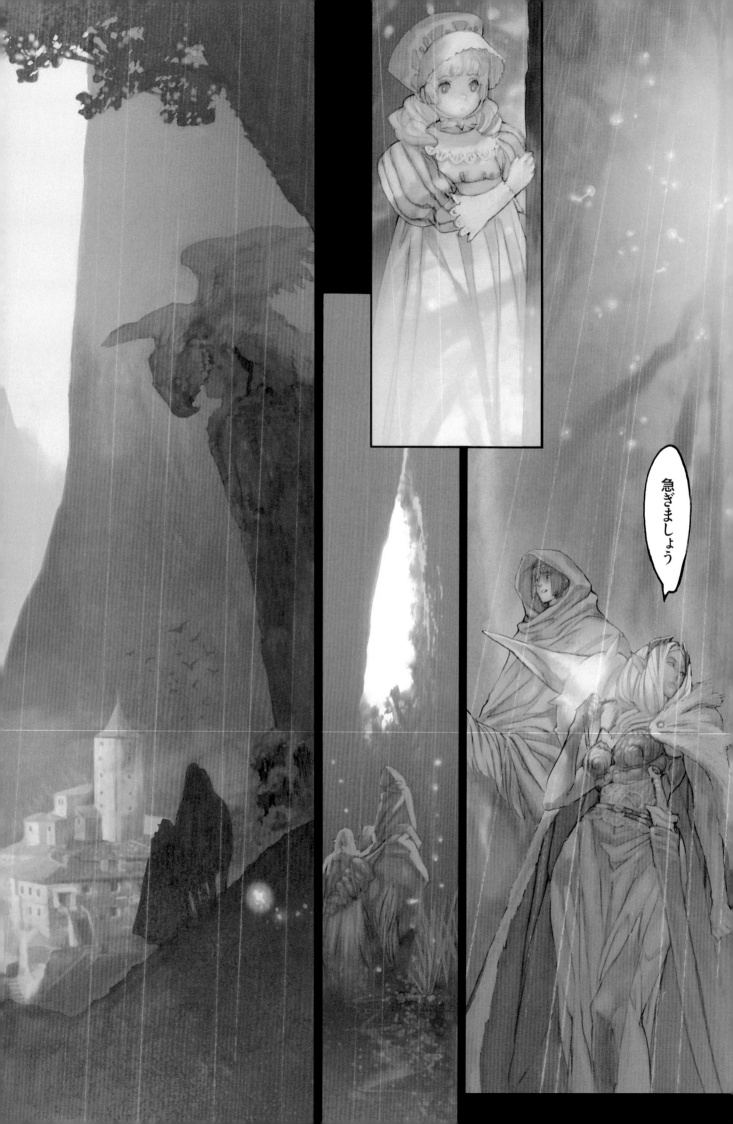

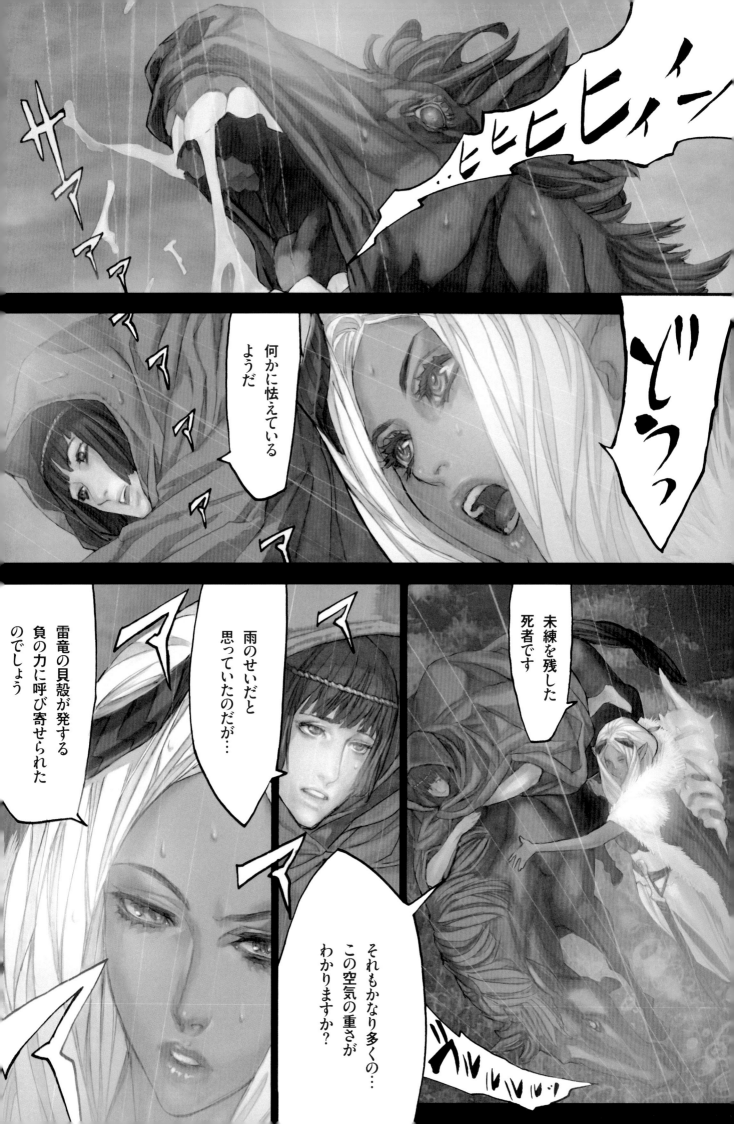

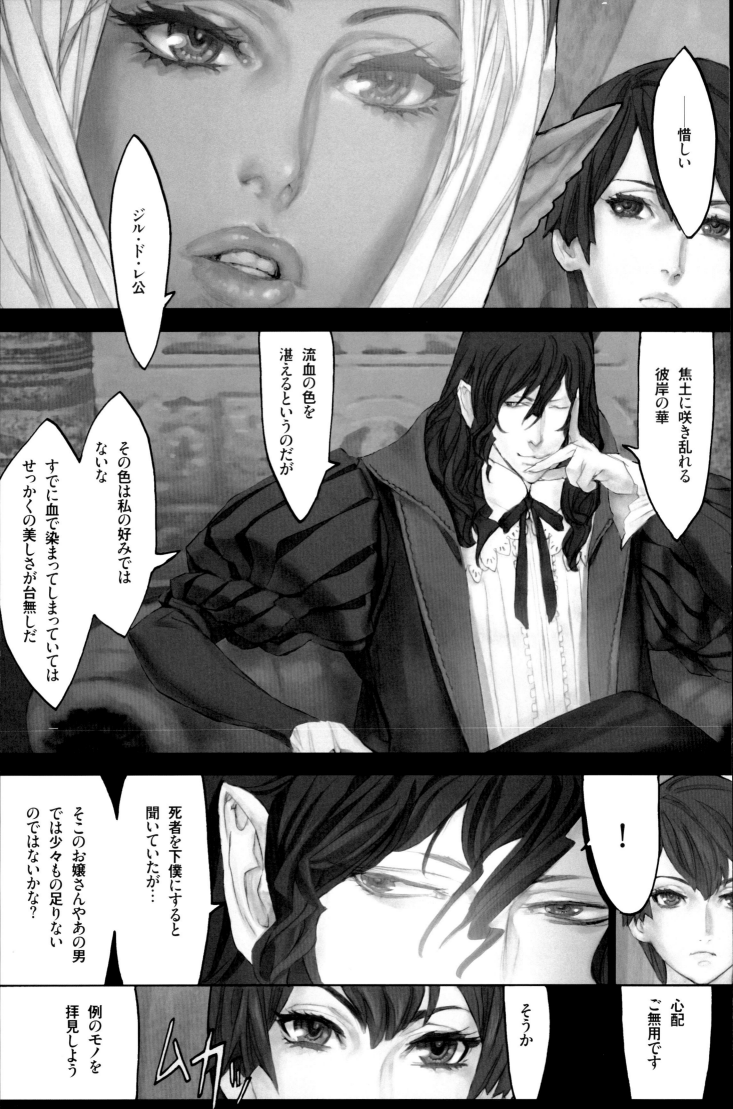

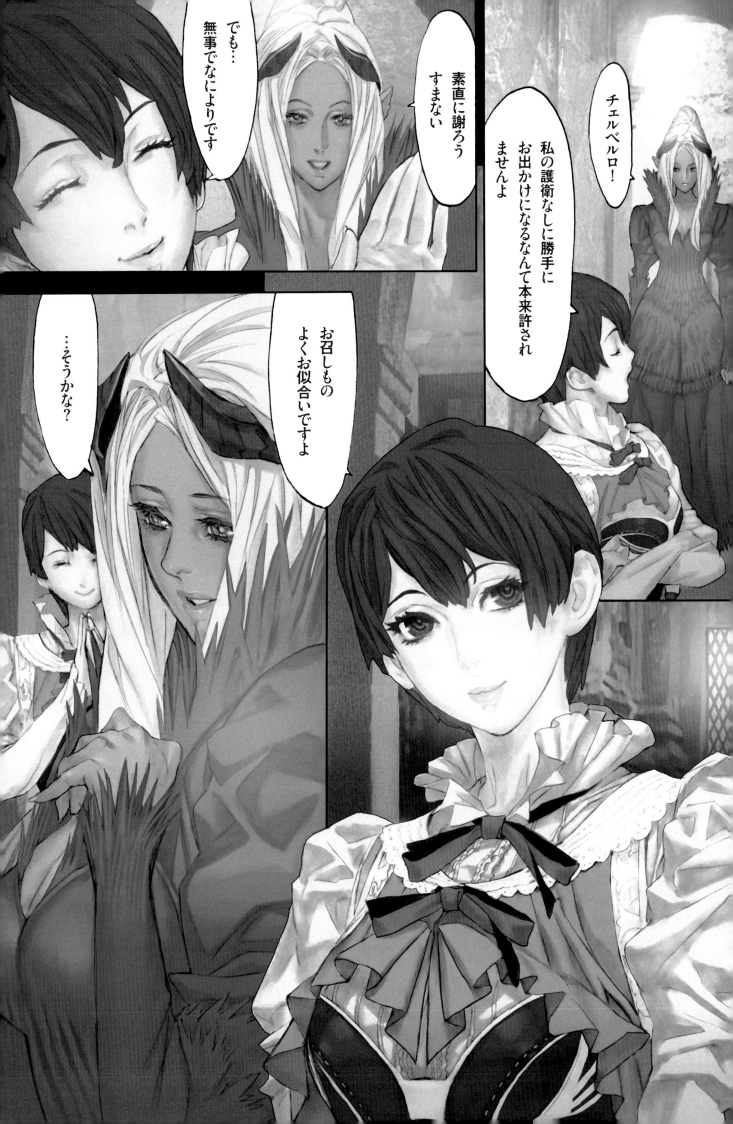

この雷竜の貝殻さえ
あれば数千の死者を
呼び集める事ができよう

姫の望むモノも
私の望むモノもだ

安心してくれたまえ溶解した
百の肉体を用意してある

かの道士ニコラ・ヴァロアは
こう仰せられた

「肉体ヲ解体シ且ツ
精神ヲ凝結セヨ」と

博識なのだな

くははっ

愚民共には
「八つ裂き公」などと
呼ばれたが

お嬢さん方にも人殺しに耽溺する
痴れ者だと思われていないか
心配だったよ

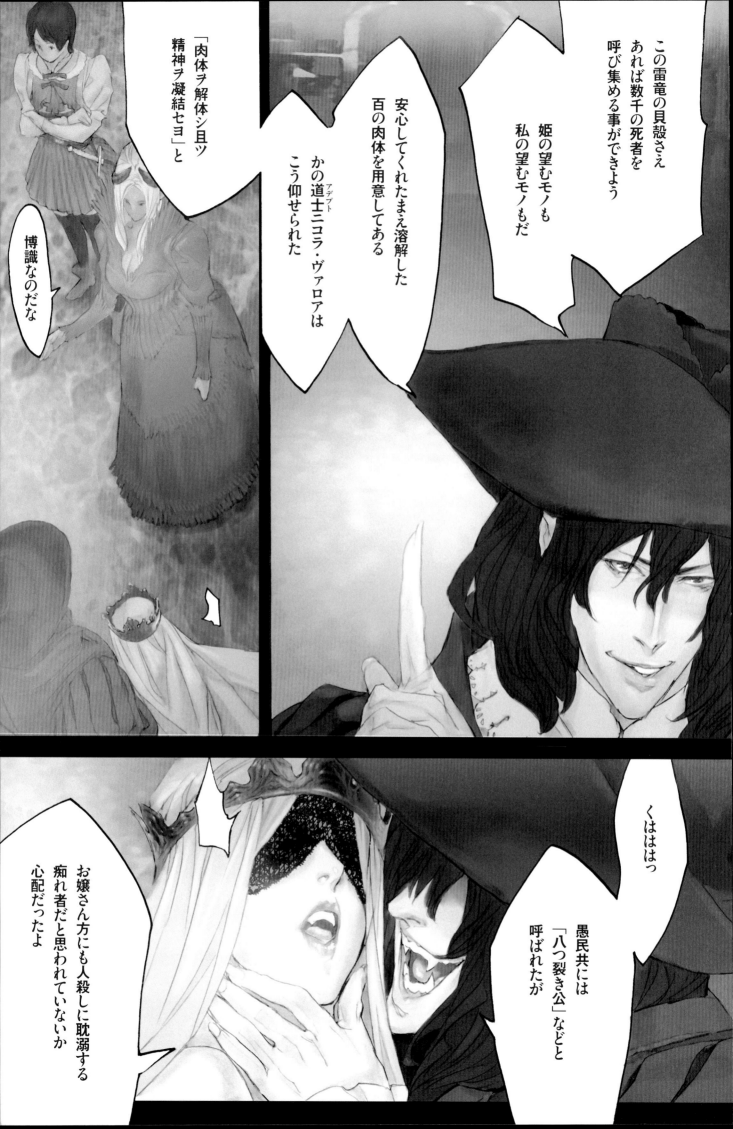

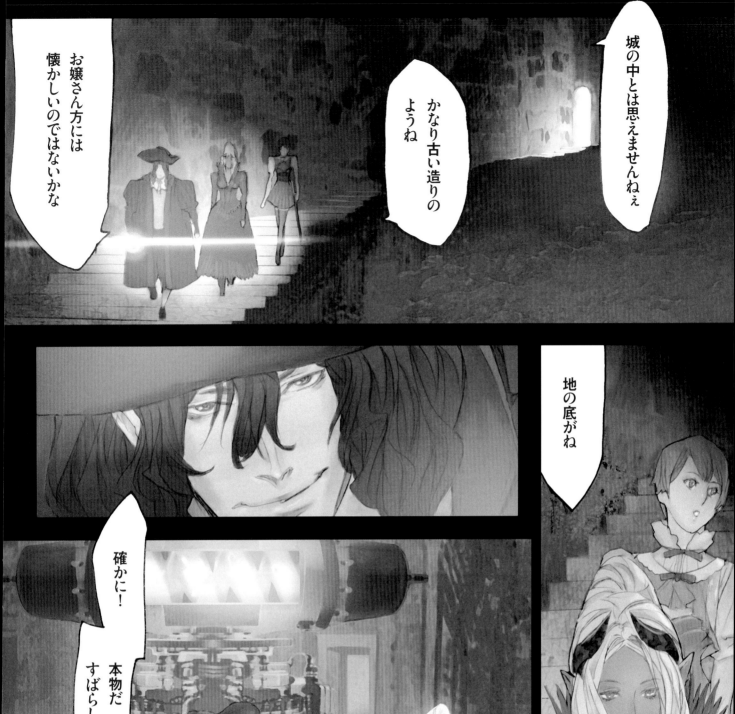

城の中とは思えませんねぇ

かなり古い造りのようね

お嬢さん方には懐かしいのではないかな

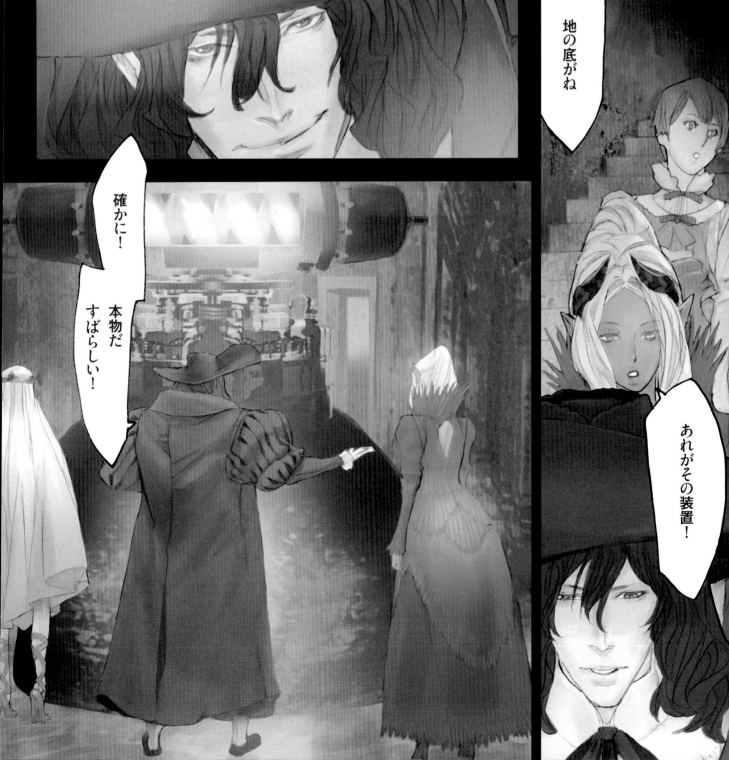

地の底がね

確かに！

本物だすばらしい！

あれがその装置！

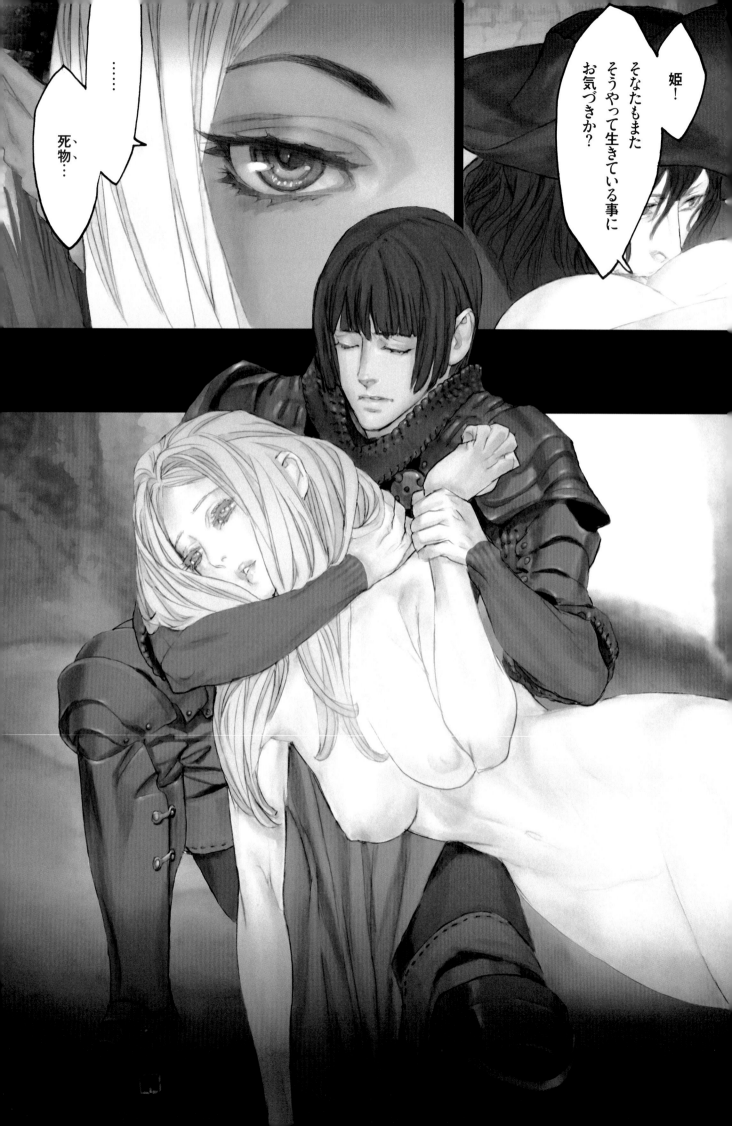

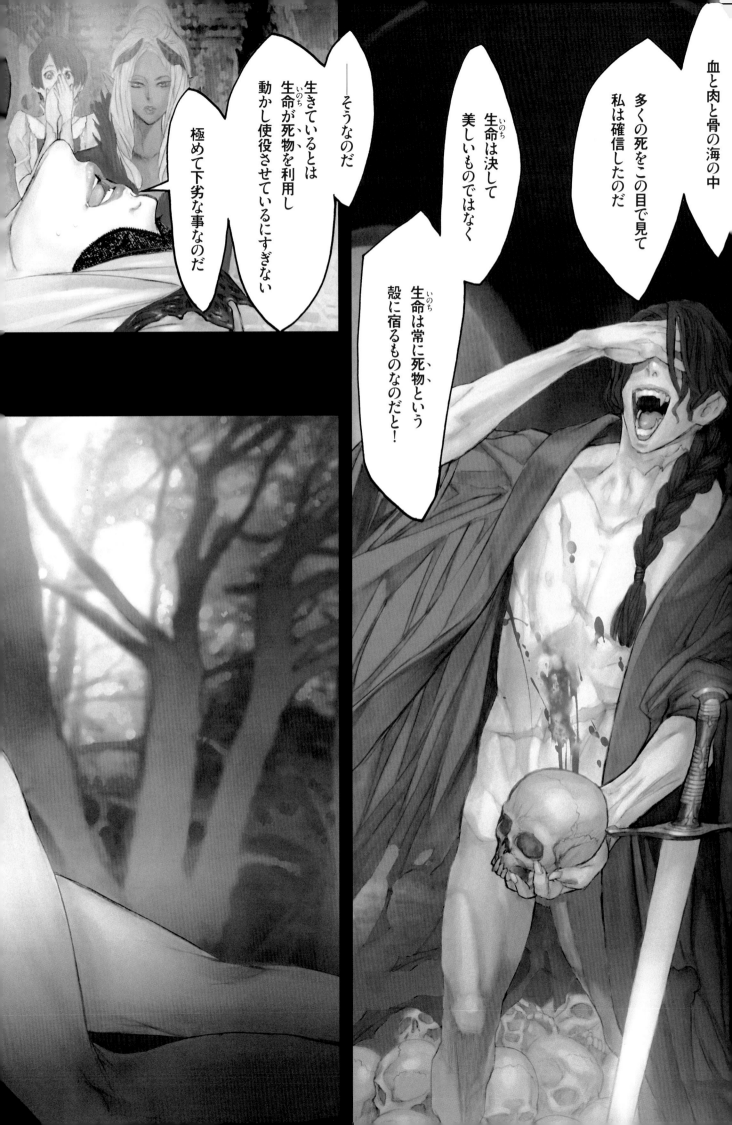

ゴオオオオオ

カッ

またあの夢

ハァ

ハァ

雨の降る日は必ず…

奇麗な貝殻――
吸いこまれそう――

…わたしは

地獄に堕ちて
当然の男だ…

人を危めた
のだから…

きゃっ！
なんて冷たいの…

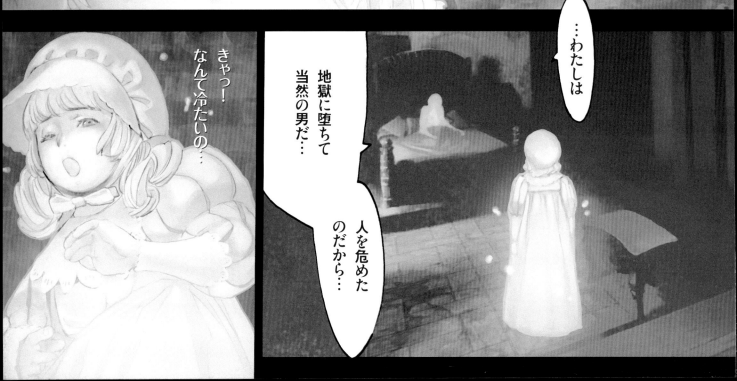

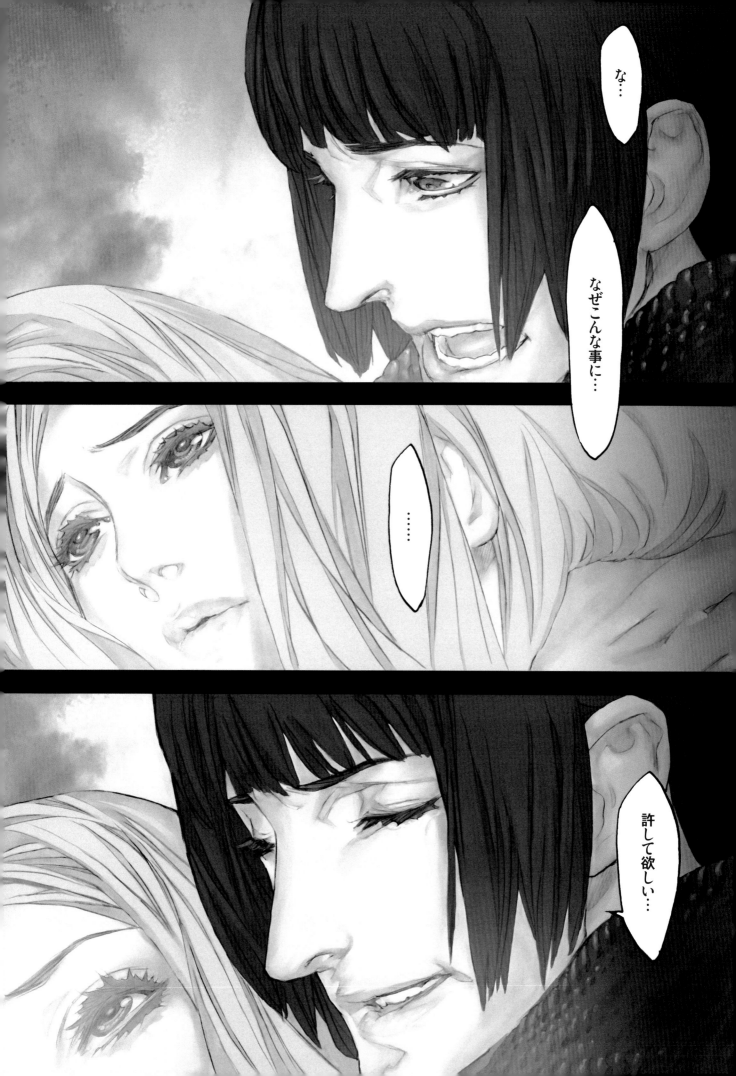

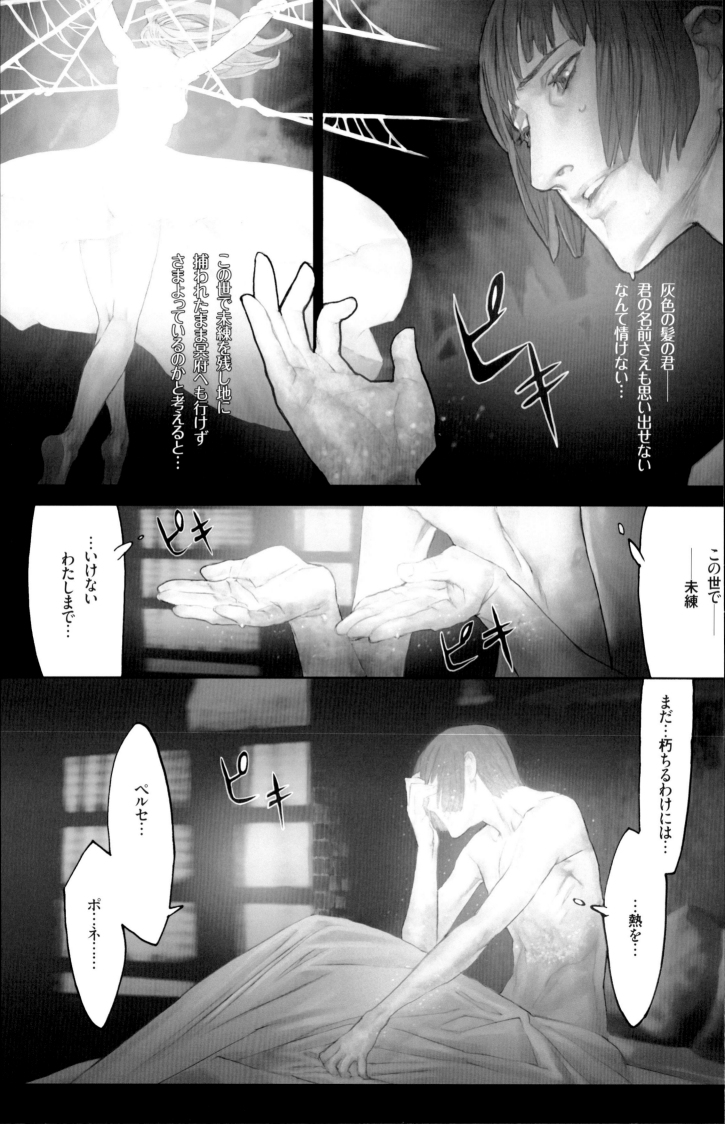

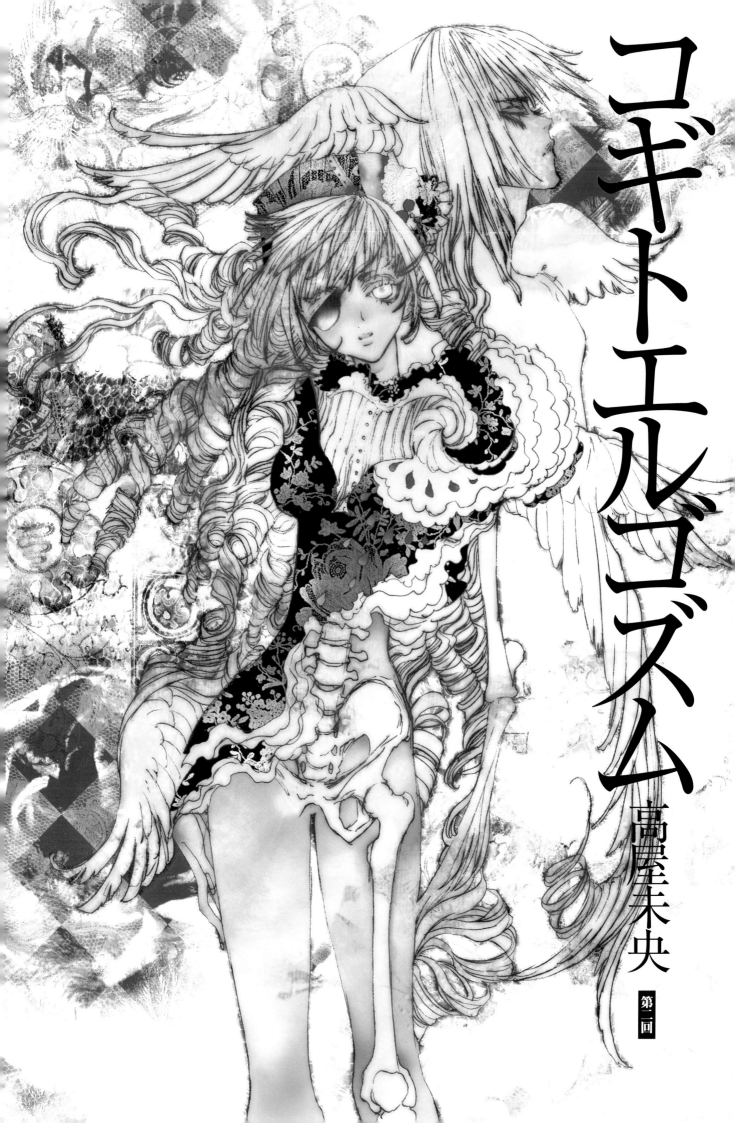

コギトエルゴズム 高屋未央 第二回

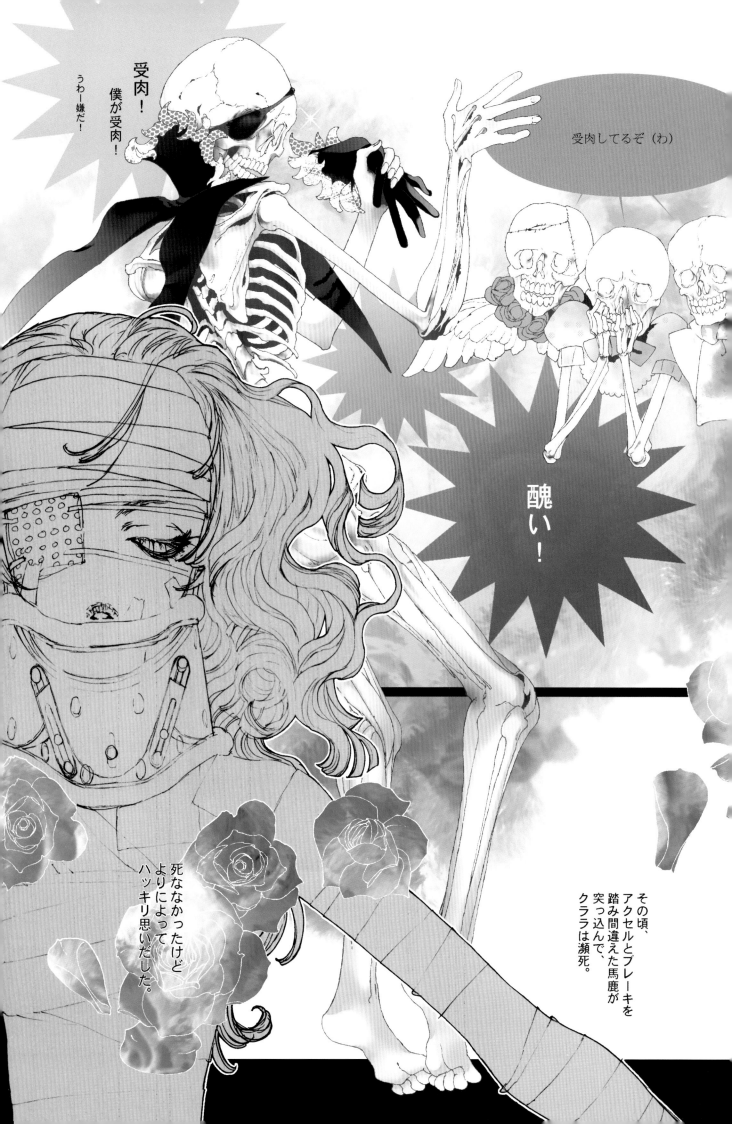

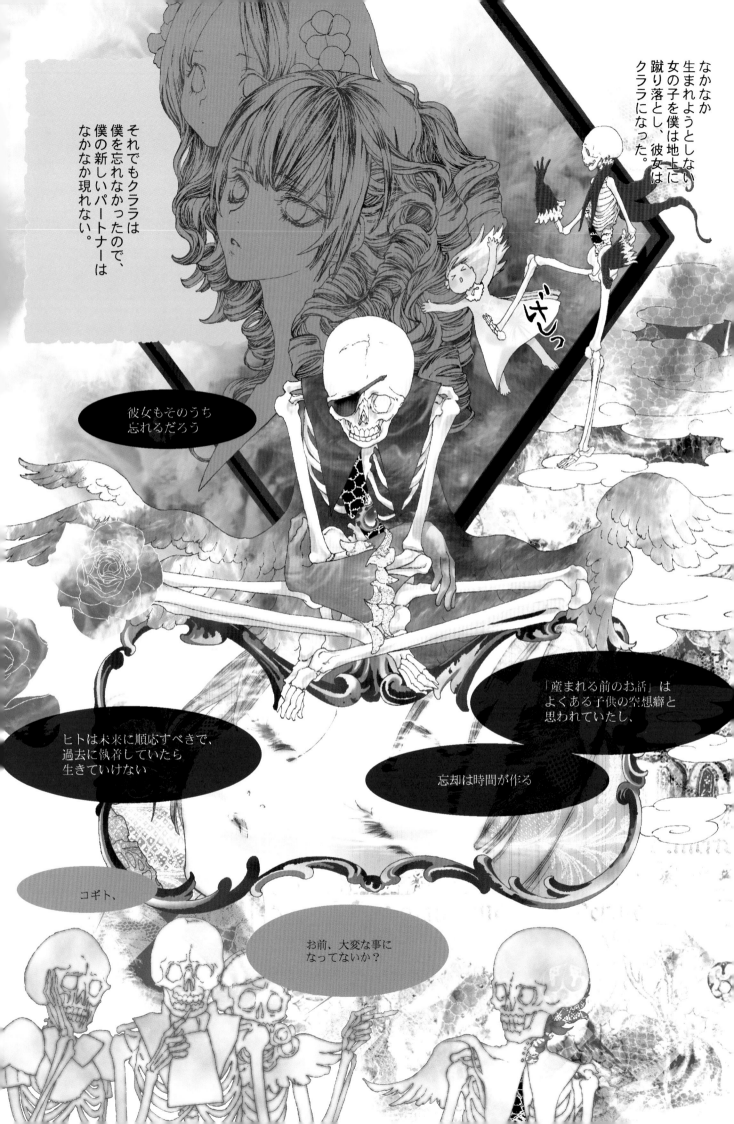

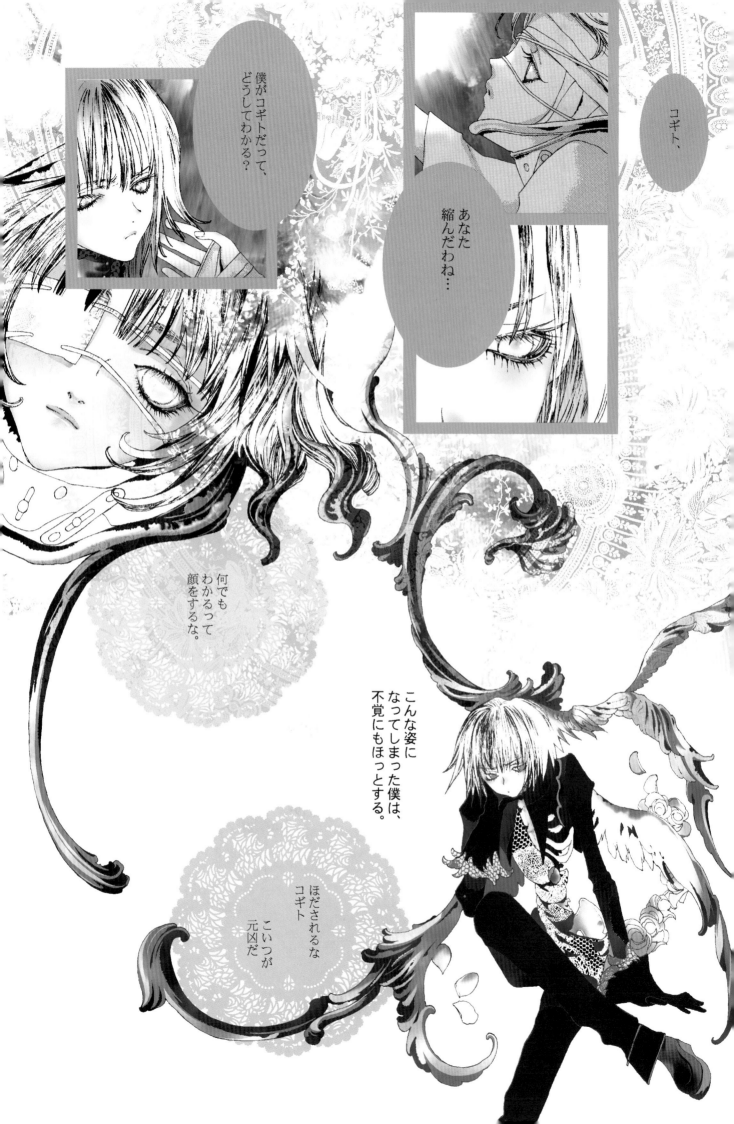

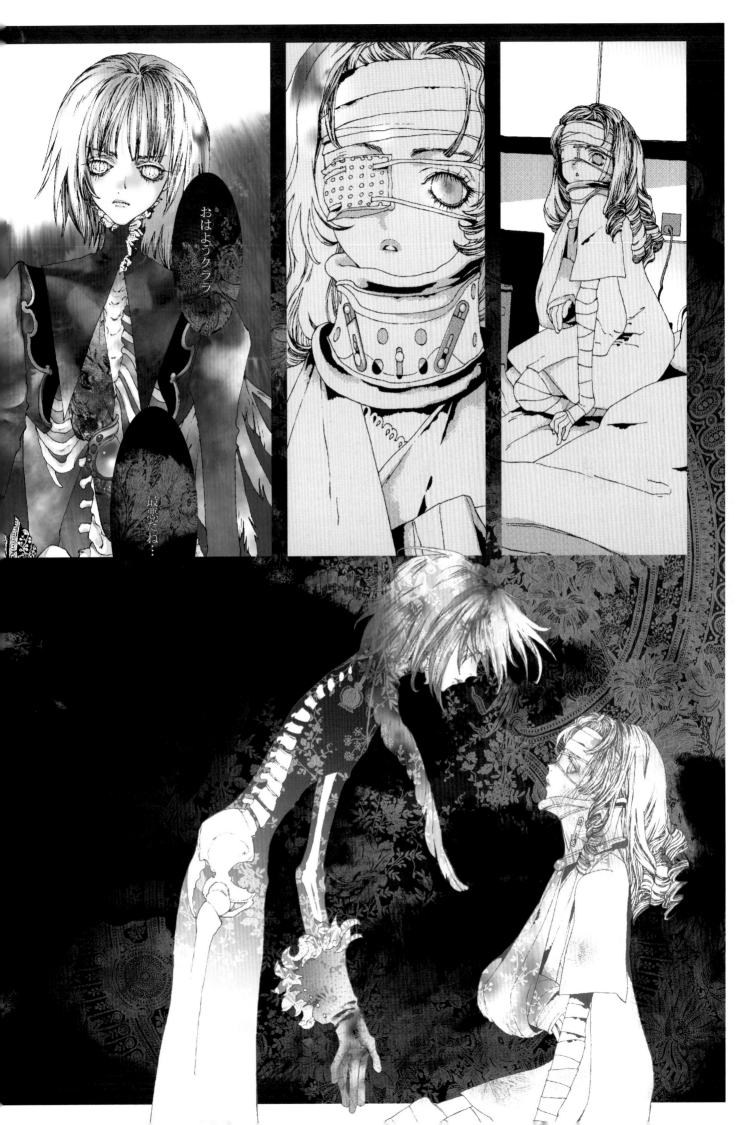

おはようクララ

最悪だね…

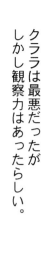

クララは最悪だったが
しかし観察力はあったらしい。

受肉のからくりに気付いて
今度は自分で自分をバッサリやった。

人間って強い。

再び蘇生したクララは
天国についてしゃべった。
医師達の背後に居た
僕を指した。
骨格標本の絵を描いた。

それは確かに僕の本当の姿だったが、
医師達にはどっちも見えなかった。

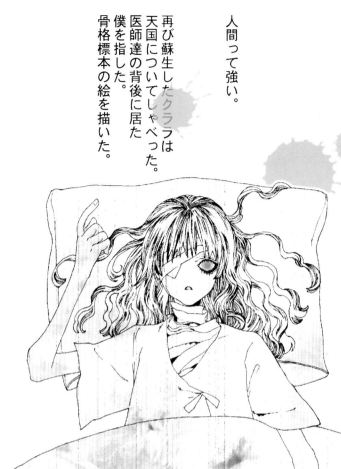

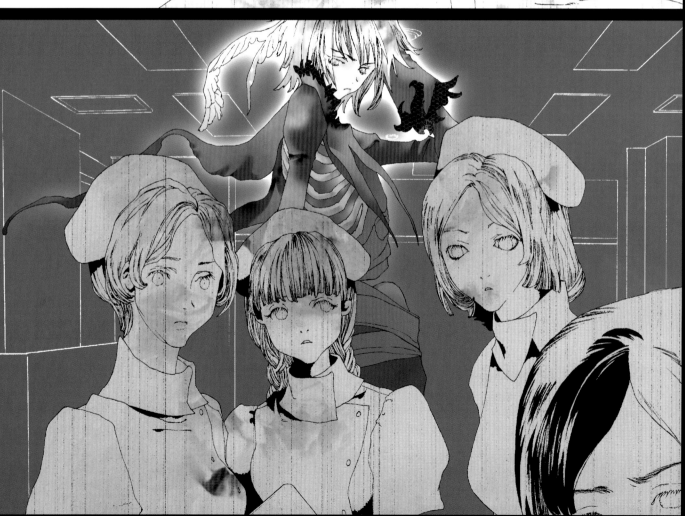

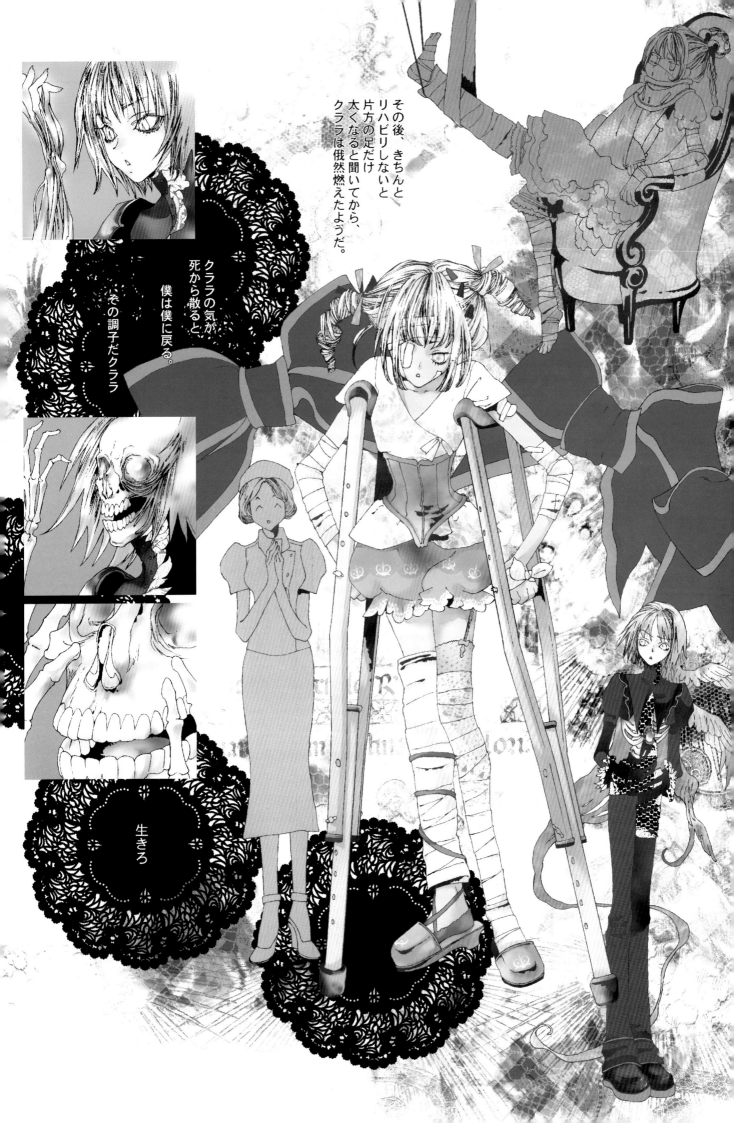

その後、きちんと
リハビリしないと
片方の足だけ
太くなると聞いてから、
クララは俄然燃えたようだ。

クララの気が
死から散ると
僕は僕に戻る。

その調子だクララ

生きろ

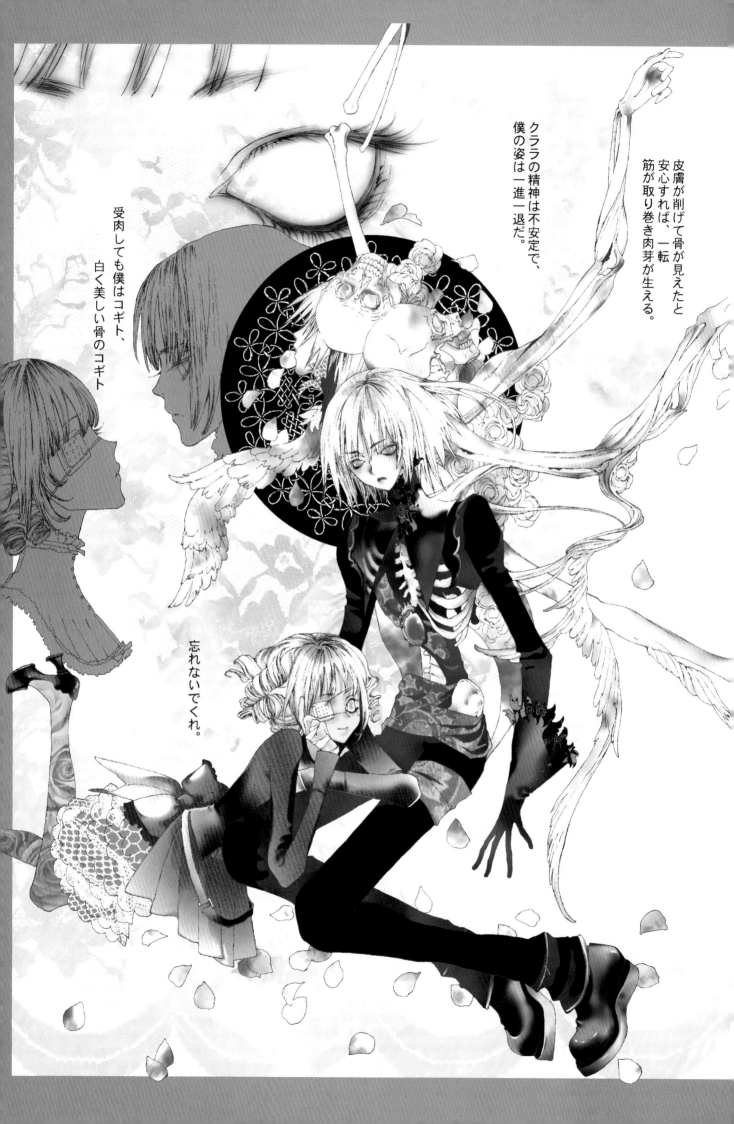

皮膚が削げて骨が見えたと
安心すれば、一転
筋が取り巻き肉芽が生える。

クララの精神は不安定で、
僕の姿は一進一退だ。

受肉しても僕はコギト、
白く美しい骨のコギト

忘れないでくれ。

のっぺらぼう

inVisible Stories

Rin Fujiki/yoShimi moriYama

——結局のところ、私は男を憎んでなどいなかった。

かつて私は親の仇を討つ為に生きていた。
そして今憎い男が目の前に居る 殺さねばならない。
その為に私は生きてきたのだ 何を躊躇うのか。
刀を振り上げ男の首をはねた。
私は生まれた頃よりの目的をはたしたのだった。
それなのに この虚無感は何か。
私の内から狂喜が沸くことはなく、心は鈍く虚ろだ。

それからの私は愛の為に生きていた。
けれども彼女は去っていこうとした 殺さねばならない。
二人の愛を成就させるためだ 他に方法はない。
刀を振り上げ女の首をはねた。
私は完全に彼女を我が物としたのだった。
それなのに この疑問符は何か。
彼女の骸を抱いても、私の鼓動は至極平静であった。

——結局のところ、私は彼女を愛してなどいなかった。

invisible stories 4
森山 由海×藤木 稟

誰かの声が響いてくる。
ひどく懐かしい音色である。
気づくと、私は水のほとりで横たわっていた。
そこは悩みの回廊に陥るたびに、幾度となく出会った泉であった。
私は静かに死の時を待っていた。

もう動かない身体で横たわっていると、
小さな子供の手をひき、老人がやってきた。
老人は恐ろしげに、顔を持たない物の怪の話をしていた。
なんでものっぺらぼうというやつは、常に何かに化けるのだそうだ。

まことの顔を持たぬ者の生き様とは、そうした運命なのじゃ」

「この泉には何千もの人の記憶と顔（ペルソナ）とが沈んでおる。
お前が持って生まれてくることのなかったものが。
ゆえに、のっぺらぼうはここへ来て、
またここへと戻ってくるのじゃよ。
かりそめの人生を選んでは、

老人が言った。

子供は目も鼻も口も持っていなかった。
私が驚きに眼を凝らすと、幼い子供の白い顔が見えた。

その老人こそ、私が幼き日、私の手を引き、ここへ誘った者であった。
いっそう驚いたことに、私は老人の顔に見覚えがあった。

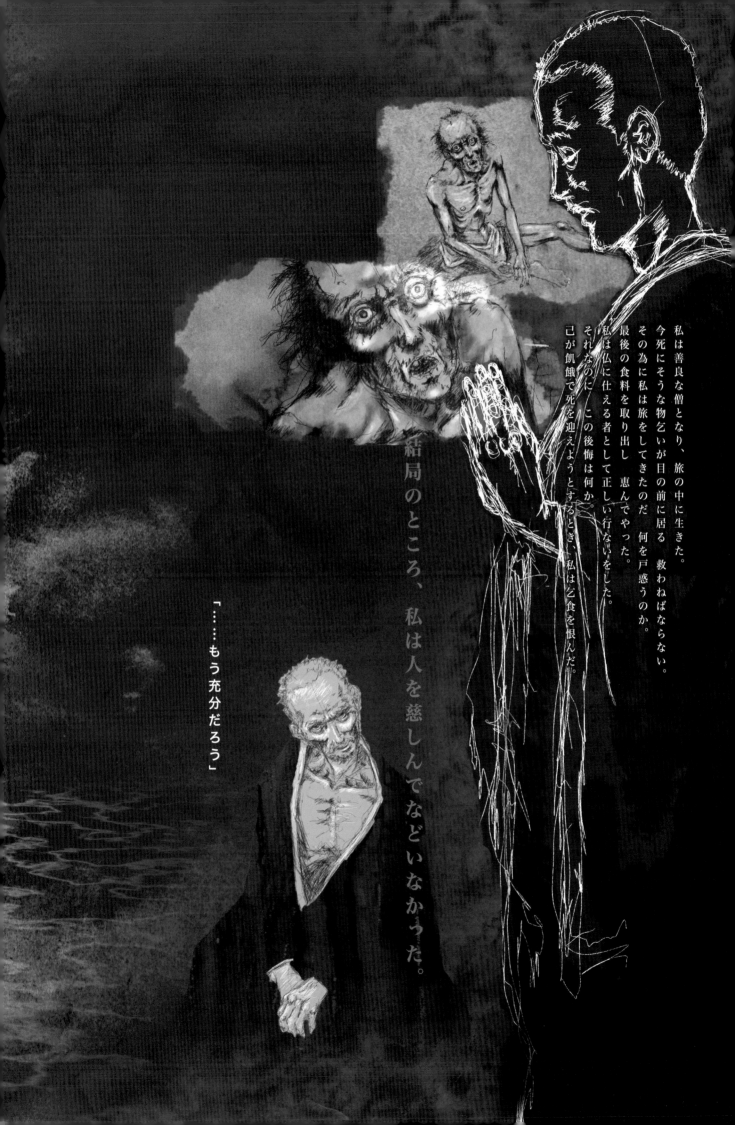

私は善良な僧となり、旅の中に生きた。
今死にそうな物乞いが目の前に居る。
救わねばならない。
その為に私は旅をしてきたのだ　何を戸惑うのか。
最後の食料を取り出し恵んでやった。
私は仏に仕える者として正しい行ないをした。
それなのにこの後悔は何か。
己が飢餓で死を迎えようとするとき、私は乞食を恨んだ。

結局のところ、私は人を慈しんでなどいなかった。

「……もう充分だろう」

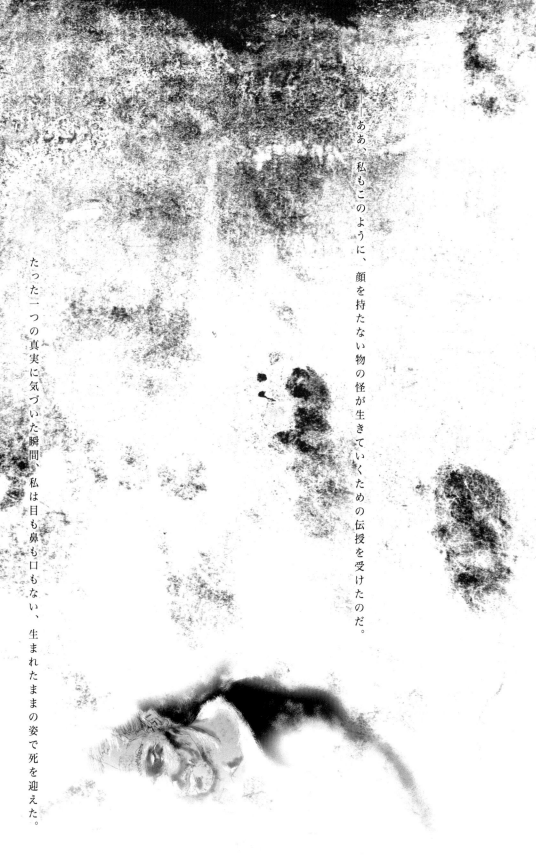

幼い子供は泉に顔をつけた。
振り返ったとき、子供は誰かの……
かりそめの人の顔を持っていた。

——ああ、私もこのように、顔を持たない物の怪が生きていくための伝授を受けたのだ。

たった一つの真実に気づいた瞬間、私は目も鼻も口もない、生まれたままの姿で死を迎えた。

森山 由海（もりやま よしみ）

装幀家、挿絵画家。
1995年、装幀挿絵画家・藤原ヨウコウとしてデビュー、2004年夏に改名。
公式サイト
y2 the web-garden(http://www005.upp.so-net.ne.jp/y2_website/)

藤木 稟（ふじき りん）

小説家。
代表作に、"探偵・朱雀シリーズ"（徳間書店）、"陰陽師鬼一法眼シリーズ"（光文社）など多数。
『SUZAKU』（作画・坂本一水、幻冬舎コミックス）『ヴァーチャル・ビースト』（作画・星野和歌子、角川書店）
など、マンガの原作でも活躍中。

pages 101-112
"Faint Sigh of the Enchanted Princess"

by Shigeki Maeshima

Born in 1974, Shigeki Maeshima is an illustrator who is well known for his serial story "Dragon Fly" in the magazine *robot* (Wanimagazine) and illustrations for novels, such as *Tatakau Shisho to Kuroari no Meikyu* ("Fighting Librarian and Labyrinth of Black Ants," Shueisha Super Dash Bunko). He also designs image boards of animation characters and video games. The serial "Faint Sigh of the Enchanted Princess" is the story of forbidden love between a princess of the enchanted world and a deceased prince. The more intimate their dangerous relationship becomes, the more enemies they have to confront. The princess uses people, such as villains who have fallen into hell. The black horse is also dead. Maeshima uses graphical subjects, such as water and woods as natural elements in the setting. The scenes effectively illustrate moments of transition between stillness and motion.

pages 113-120
"Cogito Ergo Sum"

by Miou Takaya

Born in Aichi Prefecture, Japan, Miou is a manga artist and illustrator. In 1993, she debuted as a book designer for "Kaihouyouembu—Episode Suzaku" (by Minako Fuji, Tokuma Novels). Her major manga works include "Kikaijikake no Osama (Mechanical King)" (Taiyotosho) and "Opioid Substance Endorphin" (Taiyotosho). She is also noted for her illustrations in "Muma no Tabibito" (by Mayumi Shinoda, Hakusensha), "Otosareshi Mono" (by Mayumi Shinoda, Tokuma Dual Bunko) and "Sharian no Maen" (by Yuki Rin, Shueisha Cobalt Bunko). Her picture collections include "Tengokukyo" and "Seishozu" (both from Bijutsu Shuppan-sha). In this sequel of "Cogito Ergo Sum," Clara, the main character, reveals her flesh coming out of her body, destroys herself, and is reborn. Miou greatly impacted many *Comickers* magazine readers.

pages 121-124
"Noppera-bou" (Faceless Ghost)

by Yoshimi Moriyama and Rin Fujiki

Yoshimi Moriyama started in 1995 as a binder and illustrator under the name of Yoko Fujiwara. She changed her name in the summer of 2004. Rin Fujiki is a novelist whose major works include "Detective Suzaku Series" (Tokuma Shoten), "Onmyoji Kiichi Hogen Series" (Kobunsha), and many others. She also writes actively for mangas, such as "Suzaku" (Drawing: Issui Sakamoto, Gentosha Comics), "Virtual Beast" (Drawing: Wakako Hoshino, Kadokawa), and others. "Noppera-bou" tells the story of a miserable man who lives to avenge his parents. He destroys any being that touches his soul. He becomes a devout monk and sets out on a journey, where he meets a man carrying a small child. He learns about the lives of Noppera-bou, the faceless ghosts, who disguise themselves and live transitory lives. His encounter with the man and the child will soon reveal something enchanting about his past.

Index